C000293327

CENTRAL MIDDLESBROUGH

THROUGH TIME

Tosh Warwick

AMBERLEY PUBLISHING

This book is dedicated to my uncle Neil Harvey who passed away in November 2011 at the age of fifty-four. His memories of Middlesbrough through time from my childhood to his last days have inspired this celebration of the town.

First published 2013

Amberley Publishing
The Hill, Stroud, Gloucestershire, GL5 4EP
www.amberley-books.com

Copyright © Tosh Warwick, 2013

The right of Tosh Warwick to be identified as the
Author of this work has been asserted in accordance with
the Copyrights, Designs and Patents Act 1988.

ISBN 978 1 4456 1060 3

All rights reserved. No part of this book may be reprinted
or reproduced or utilised in any form or by any electronic,
mechanical or other means, now known or hereafter
invented, including photocopying and recording, or in
any information storage or retrieval system, without the
permission in writing from the Publishers.

British Library Cataloguing in Publication Data.
A catalogue record for this book is available from the
British Library.

Typesetting by Amberley Publishing.
Printed in Great Britain.

Introduction

In 1862, Middlesbrough was described as an 'infant Hercules' by William Gladstone on his visit to the new industrial heartland and epitome of England's enterprise. The 'Ironopolis' had grown into a burgeoning centre of industry, yet – even as one of the iron manufacturing capitals of the nation – the boom of the town had not reached its zenith.

It was a far cry from the small agricultural hamlet of twenty-five people that sat on the site in 1801. The extension of the Stockton & Darlington Railway to what was known as Port Darlington in 1829, set in motion the birth of industrial Middlesbrough. Led by the Quaker businessman Joseph Pease, the Owners of the Middlesbrough Estate developed a town along a gridiron plan to accommodate the new community, who would provide the labour to support the coal shipping operation. With it, a town hall, a Customs House and a market place were established during the next two decades, while Middlesbrough Dock, opened in 1842, provided the hub of activity as Middlesbrough looked to rival Newcastle and Sunderland in coal shipping. The population increased from 150 in 1831 to 5,463 by 1841, and a body of improvement commissioners were made responsible for the running of the growing town.

The real surge in growth was heralded by the discovery of substantial ironstone deposits in the nearby Cleveland Hills in 1850, which facilitated the development of high-intensity iron manufacture in Middlesbrough. Previously, the town had struggled to compete with its neighbours in coal shipping and its iron industry had almost collapsed as Bolckow Vaughan faced difficulties in the 1840s, but the vast iron ore reserves brought new opportunities and the potential for phenomenal economic prosperity.

The Victorian 'boom town' expanded rapidly with ironworks and mills appearing along the banks of the River Tees in the 1850s, including the works of Bell Brothers, Cochranes and Sir Bernhard Samuelson. The town was granted its Charter of Incorporation in 1853 as the municipal authority matured and the population expanded rapidly, with economic migrants flocking to the area seeking employment opportunities in the burgeoning industry. The population rose from 7,631 in 1851 to 18,892 a decade later, to 39,284 in 1871, settling at 55,934 in 1881. So rapid was the town's growth that comparisons were made with the frontier American and Australian boom towns; the historian Asa Briggs reflected in his 1963 *Victorian Cities* that Middlesbrough's development had an American or Australian ring to it, for it was about this time that gold was discovered first in California (1849) and next in Victoria (1851). Whole new communities came into being with a rough but vigorous life of their own. Middlesbrough was, in a sense, the 'British Ballarat'. Certainly, despite the inferior appeal of iron compared to gold, the Cleveland statistics were felt to be breathtaking by all the writers on the British economy in newspapers and periodicals.

Iron and later steel manufacture would go on to dictate the town's cultural, demographic, economic, political and social make up for over a century. Even though other industries emerged

during the early decades, including Linthorpe Pottery, a salt works and various retailers, to provide for the needs of the new community, manufacturing dominated. The town's first mayor and MP was Middlesbrough's leading ironmaster Henry Bolckow, while organisations such as the Chamber of Commerce, the Cleveland Club, and the Literary and Philosophical Society were dominated by industrialists.

In 1875, Arthur John Dorman and Albert de Lande Long established Dorman Long and led the way with steel manufacture in the area. The steel industry brought with it new economic opportunities and markets for the produce of steel around the world, with Dorman Long establishing a worldwide reputation for bridge building, giving the world landmarks such as the Sydney Harbour Bridge and Newcastle's Tyne Bridge. In the late nineteenth and early twentieth centuries, the town matured as new key individuals and organisations gained an increasingly prominent role in its governance. Men such as the retailer Amos Hinton emerged as prominent figures alongside and in place of the industrialists who had dominated the early life of the town.

Middlesbrough was made a county borough in 1889, the same year as the town's grand neo-Gothic town hall and municipal buildings were opened by the Prince and Princess of Wales. During the ensuing decades, the town's physical make up changed markedly, with new larger houses emerging on the southern boundaries of the town, which extended with the absorption of the urban district of North Ormesby. Significant civic and industrial buildings and structures appeared, including the Dorman Memorial Museum (1904), Lady Bell's Middlesbrough Winter Garden (1907), Tees Transporter Bridge (1911) and Middlesbrough Free Library (1912).

The outbreak of the First World War heralded a period of intense industry as the iron and steel firms devoted much of their output to war purposes, Middlesbrough serving as one of the most important munitions centres. The First World War also brought significant loss of life, which continues to be commemorated in the form of the cenotaph (1922) outside Albert Park.

The interwar years proved to be challenging times for the area's manufacturing industry in line with national trends. Major upheavals in the steel industry saw amalgamations, rationalisation, relocation downstream and then the slump in the 1930s. However, the interwar period also saw the development of leisure and social provision in and around the town, including Stewart Park coming into the town's possession in 1923. The opening of the Tees (Newport) Bridge (1934) also provided vital access to the growing chemical industries on the north side of the river.

The Second World War saw Middlesbrough hit by 12 raids with 78 people killed, 318 buildings destroyed, 1,210 damaged and 7,337 houses damaged, and landmarks such as the Tees Transporter Bridge, town hall and Middlesbrough railway station were hit during the strikes. The industries again played a vital part in the war effort, including supplying munitions and Mulberry Harbours.

Post-war Middlesbrough witnessed extensive redevelopment with new housing following extensive slum clearance, as well as new commercial and municipal buildings, most notably in the 1970s. The 1980s saw the configuration of the town change further with the construction of the A66, resulting in the demolition of one of Middlesbrough's landmarks, the Royal Exchange. Recent decades have witnessed the development of Middlehaven, with the Riverside Stadium opening in 1995, Middlesbrough College relocating next to Middlesbrough Dock in 2008, and extensive digital industries emerging in old and new buildings. The heart of the town too has undergone renovation with the expansion of Teesside University, the realignment and renovation of Centre Square and the opening of Middlesbrough Institute of Modern Art (mima) in 2007. The area once hailed as 'Ironopolis' continues to face challenges but strives forward, embodying Middlesbrough's civic motto Erimus – 'We shall be'.

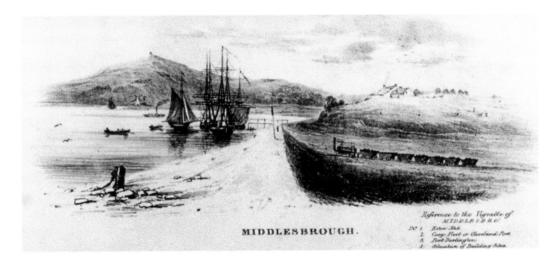

MIDDLESBROUGH.

Reference to the Vignette of
MIDDLESBRO'
Nº 1. Eston Nab
2. Cargo Fleet or Cleveland Port
3. Port Darlington
4. Situation of Building Sites

Early Middlesbrough, c. 1820s/1830s

Despite historic foundations in the Middle Ages, including the establishment of a priory on the site of the existing town in the twelfth century, modern Middlesbrough has been defined by industrial development dating back to the early decades of the nineteenth century. Developed by the Pease family-led Owners of the Middlesbrough Estate, what was previously known as Port Darlington evolved into a centre for coal shipping, centred upon the River Tees and new docks. Here, the plans can be seen alongside the town as it appeared during its early development.

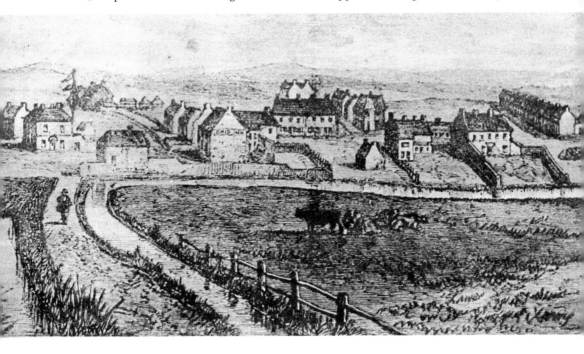

Industry

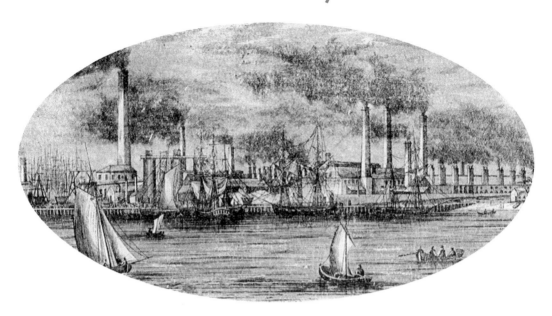

Ironworks

The emergence of the iron industry in the town, led by developments such as Bolckow Vaughan's first ironworks in 1841, resulted in Middlesbrough gaining the nickname 'Ironopolis'. Having weathered the storm in the late 1840s when the iron industry struggled and almost disappeared, the town burst onto the national scene as a Victorian 'boom town' in the 1850s, following the discovery of iron ore in the Cleveland Hills.

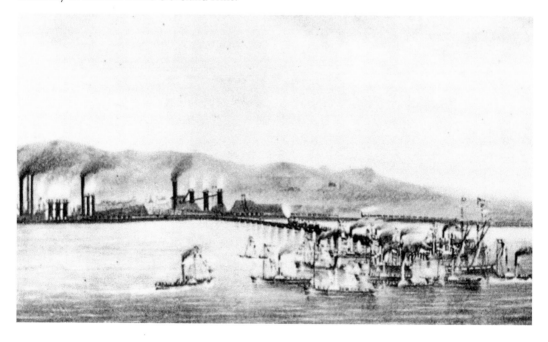

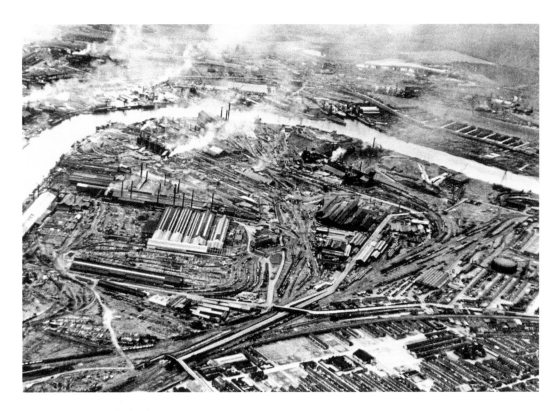

Ironmasters' District

The Ironmasters' District emerged as the central manufacturing hub as firms, including Bolckow Vaughan, Dorman Long and Gjers Mills, established plants along the banks of the River Tees. Here, various iron and steelworks are seen from the air, complete with the smoke that polluted the Middlesbrough air. The area is now home to Riverside Business Park, but remnants of the old industry remain, including William Lane Foundry, established in 1862.

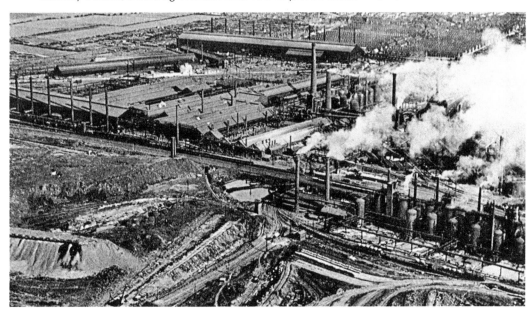

Marton Road, *c.* 1859

As industrial production increased the town developed rapidly, with migrant workers from across Britain flocking to Middlesbrough. The town was hailed by William Gladstone during an 1862 visit as an 'Infant Hercules'. As well as the skyline's marked change, owing to the works of the various iron companies, the physical environment of the town changed too. Here the early landmarks of the town can be seen, including St Hilda's church and the first dock tower, a far cry from the hamlet centred upon the Middlesbrough farmhouse, which was demolished in the 1840s.

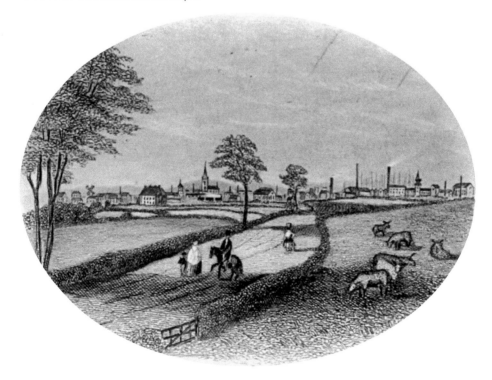

Town Centre, 1829 and 1882

The town's population expanded rapidly in the nineteenth century from just 25 in 1801, to 55,934 in 1881, and over 91,000 by 1901. Middlesbrough's original grid plan was not suitable for the rapidly increasing population as the town sprawled southwards.

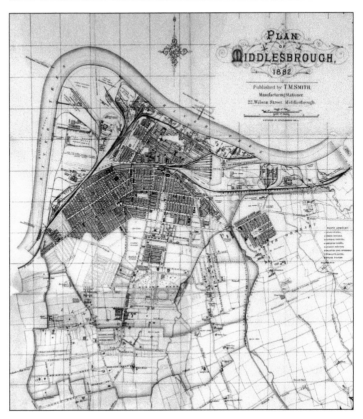

ORIGINAL PLAN OF MIDDLESBROUGH, 1829.

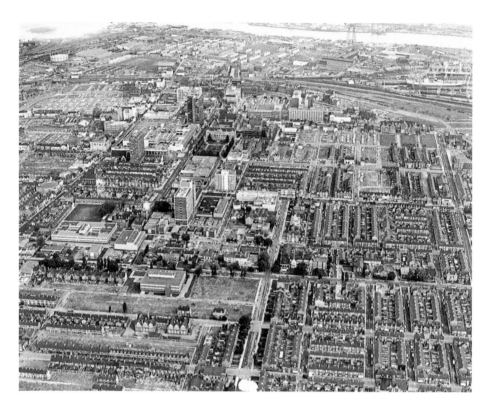

Aerial View Looking Northwards

The changes in the landscape of the town over recent decades are apparent in these two aerial photographs looking northwards. While the Tees Transporter Bridge is one of the most obvious mainstays, the grassed land to its immediate west shows the vast changes that have occurred in the St Hilda's area of the town from the 1970s to the modern day. To the south, the expanse of Teesside University can be seen, with new buildings having been constructed.

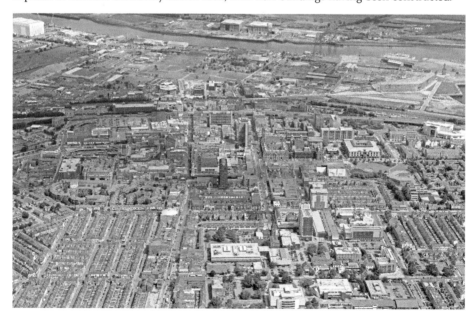

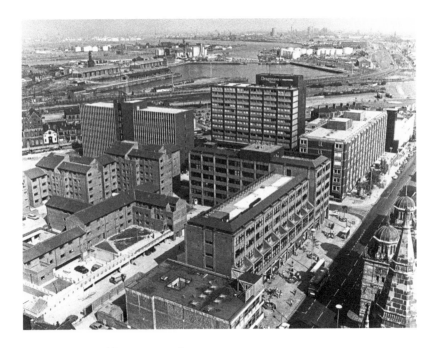

Aerial View Looking Eastwards

These different views looking towards Middlesbrough Dock, to the east of the town centre, show how Middlehaven has changed. The oldest photograph shows the dock empty, with the Dragonara Hotel (now the Thistle Hotel) overlooking the newly constructed Vancouver House and new Central Mews housing development. The developments of Middlesbrough Football Club's Riverside Stadium can be seen in the more recent photograph taken in 2001, although Middlesbrough College is yet to be built.

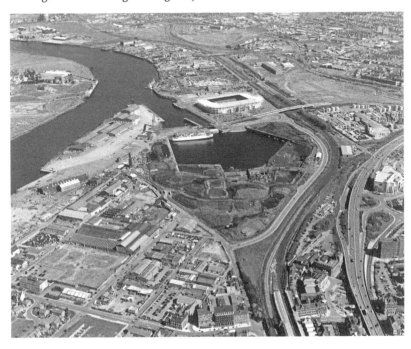

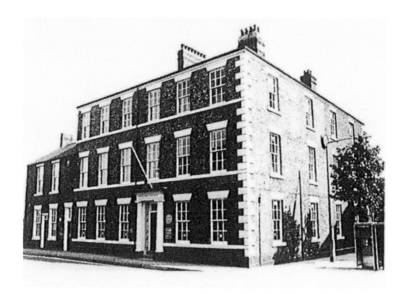

Cleveland Buildings

Made up of two adjoining houses, the buildings were the homes of Henry Bolckow and John Vaughan, the founders of the Cleveland iron trade. The ironmasters, who married sisters, lived next door to one another throughout the 1840s and 1850s, before following the lead of industrialists elsewhere in moving out to the countryside and adopting a gentrified lifestyle. The home was also home to Sir William Henry Crosthwaite, chairman of the Tees Conservancy Commissioners from 1942 to 1945.

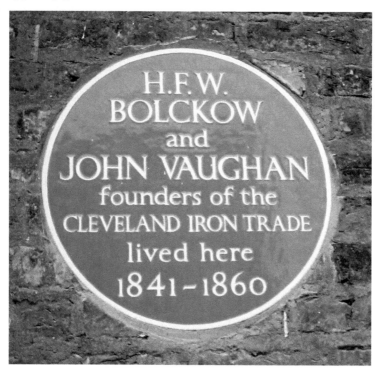

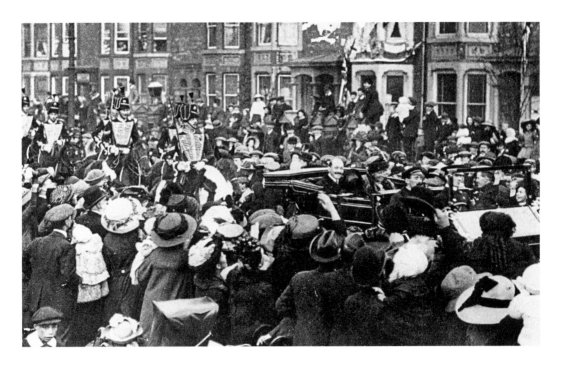

Queen's Terrace

The Georgian-style terraced houses are among the oldest remaining in the town. Nos 1–3 Queen's Terrace were previously the head offices of the Owners of the Middlesbrough Estate, the consortium of Quaker businessmen who established the modern town as a port. The offices can be seen here in 1911, with Prince Arthur of Connaught passing proceeding to the Tees Transporter Bridge for the landmark's opening ceremony. Having fallen into disrepair, the buildings have recently undergone renovation and are now used as office space.

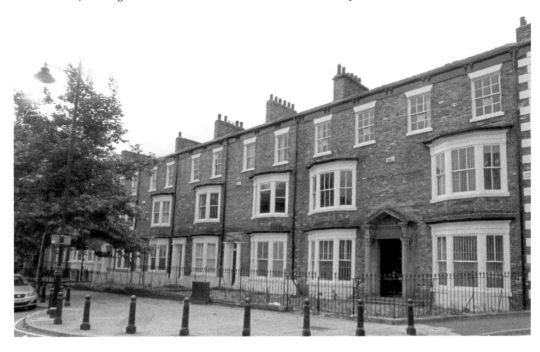

Middlesbrough Docks

Middlesbrough Dock Clock Tower

One of a succession of dock clocks that have served the site since the 1840s, the most recent incarnation dates from the early twentieth century. As well as timekeeping, the clock tower also supplied hydraulic power to operate the dockside cranes to open and close the gates. The Dock Clock is unusual in possessing only three rather than four faces – it is reputed that this is owing to employers to the north having not been willing to contribute to costs for fear employees would clock watch!

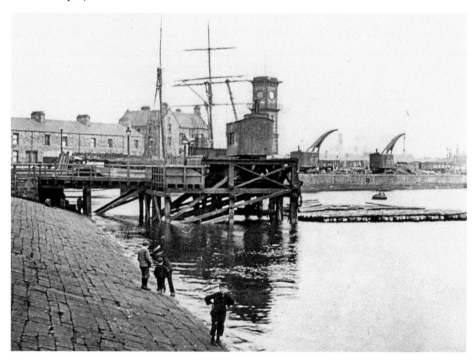

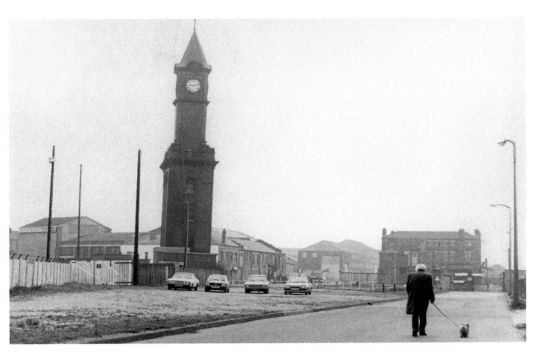

Middlesbrough Dock
Clock Tower

When Middlesbrough Dock closed in 1980, the clock tower fell into disrepair. In recent years, the wider regeneration of Middlehaven has seen the clock tower undergo renovation, although it has not been restored to full functionality. The clock tower now stands in close proximity to Middlesbrough College.

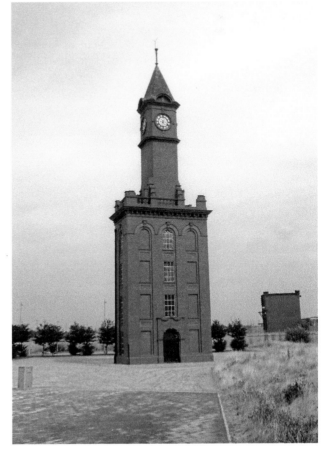

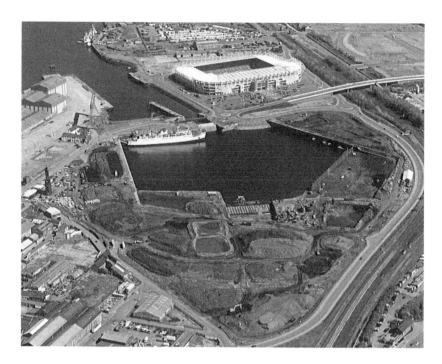

Middlesbrough Dock

Middlesbrough Dock closed in 1980, with employees transferring to join those based at Tees Dock. The site is now part of the wider Middlehaven developments, which have seen Middlesbrough College establish itselves on the site over the past decade, with thousands of students ranging from school leavers to mature learners now following in the footsteps of the dock workers of yesteryear.

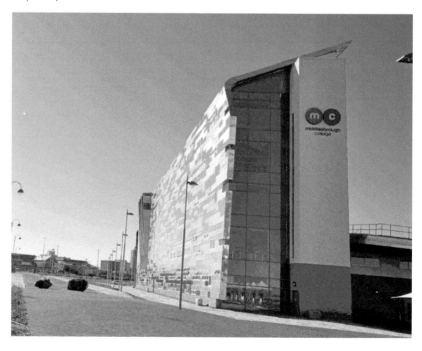

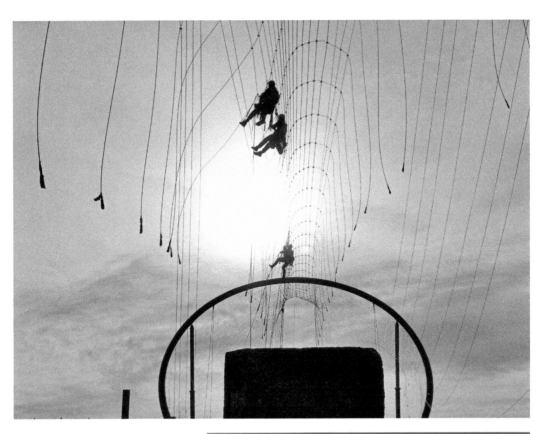

Temenos

The work of internationally acclaimed sculptor Anish Kapoor and structural designer Cecil Balmond, Temenos, meaning land cut off and assigned as a sanctuary or holy area, was constructed over four months in 2010. Thousands of metres of steel wire weave between the two steel rings to create the 164-foot-high (50m) and 360-foot-long (110m) sculpture. The £2.7-million structure, the first of the proposed Tees Valley Giants project, stands next to the old Middlesbrough Dock area and Middlesbrough FC's Riverside Stadium.

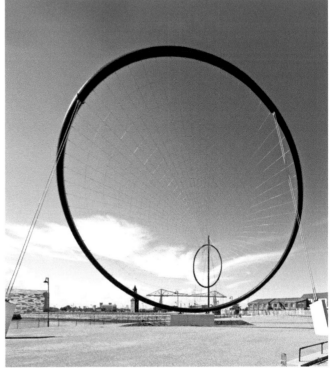

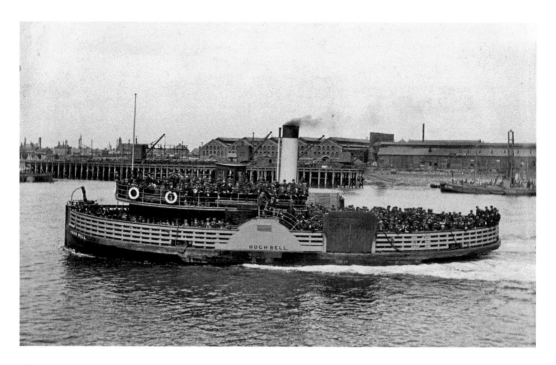

River Tees

In Middlesbrough's early days as a coal export town and then as a major iron and steel manufacturing centre, the river played a crucial role. At the end of the nineteenth century, almost 100 firms were in operation along the banks of the River Tees in the Middlesbrough area. Despite the decline in industry in the latter part of the twentieth century, the river remains active, with firms such as AV Dawson operating in the old ironmasters district of the town.

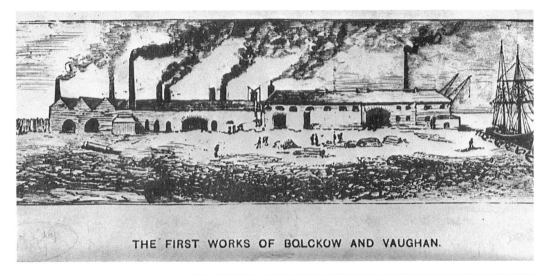

THE FIRST WORKS OF BOLCKOW AND VAUGHAN.

Vulcan Street Wall

At the southern boundary of Bolckow Vaughan ironworks and Cleveland Salt Works, the wall is all that remains from these two landmark firms. As well as the iron and salt works, Vulcan Street supported a number of major industries in the nineteenth century, including the Middlesbrough Pottery. Vulcan Street Wall was restored by Cleveland Community Task Force and Middlesbrough Borough Council in 1982, and now lines the site of Able UK.

Tees Transporter Bridge

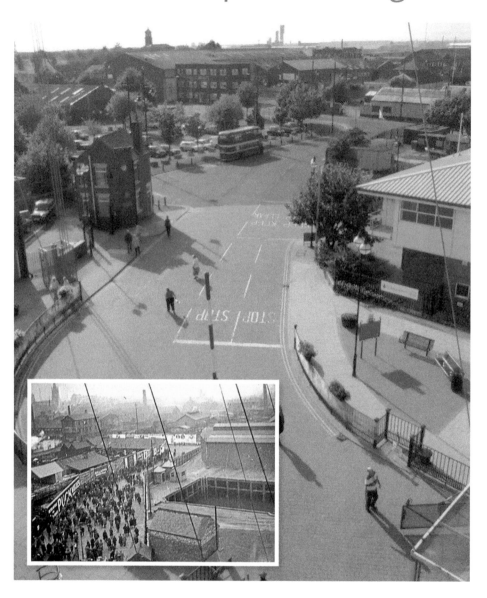

St Hilda's from the Tees Transporter Bridge

The original site upon which Middlesbrough grew up from the 1830s, this area provided the location for the town's earlier municipal, commercial and leisure premises of the town. A handful of buildings from the area remain from the nineteenth century, including the Customs House and Old Town Hall, although all the housing stock has since changed, with even the most recent developments having been demolished. Here the contrast between the area's heyday and its current state is evident: the hordes of workers can be seen leaving the Tees Transporter Bridge with St Hilda's church, the tower of the Old Town Hall and the industries in the area visible in the background.

Tees Transporter Bridge

Constructed by Sir William Arrol & Co., the bridge was opened on 17 October 1911 by Prince Arthur of Connaught. This landmark structure is the longest transporter bridge in the world. Spanning the River Tees, the gondola initially transported workers in the iron, steel and chemical industries across the river, but is now increasingly used by motor vehicles and tourists.

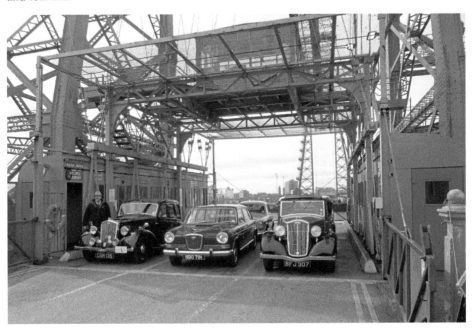

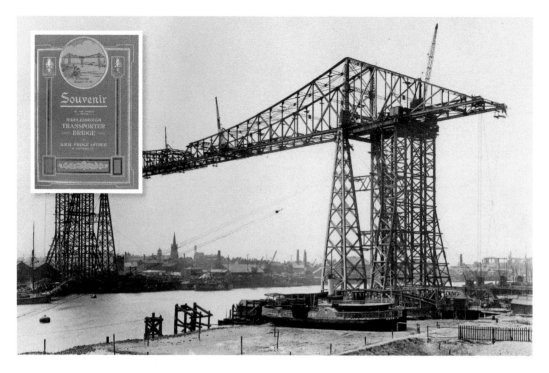

Tees Transporter Bridge

Use of the bridge peaked in 1919 with over five million users. In recent years the bridge has evolved into a location for extreme sports, including bungee jumps, zip slides and abseiling. The heritage attraction has also featured on the big and small screen, including in *Billy Elliot*, *Auf Wiedersehen, Pet* and *Who Do You Think You Are?*

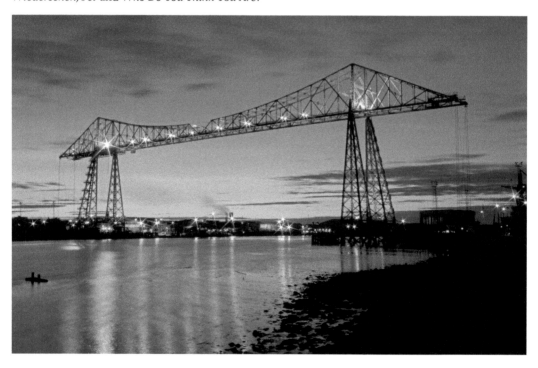

Port Clarence

Although not part of Middlesbrough, Port Clarence is linked to the town in the south by the landmark Tees Transporter Bridge, with the industries along the north bank of the river having been historically defined by the 'Ironopolis'. Bell Brothers' works were previously situated on the north banks of the Tees, with a ferry service initially providing a crossing for workers from Middlesbrough before the construction of the bridge.

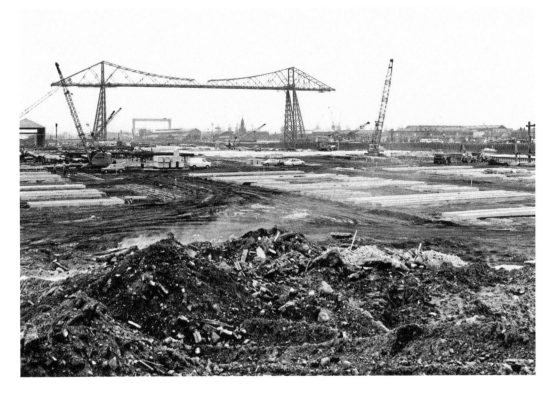

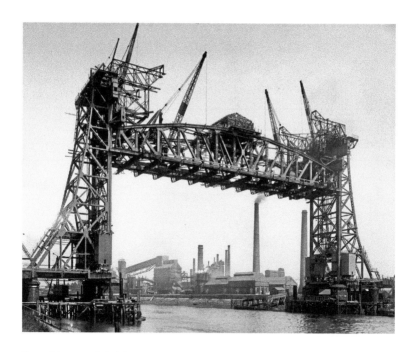

Tees (Newport) Bridge

Opened on 28 February 1934 by the Duke of York, the Tees (Newport) Bridge was the first vertical lift bridge of its type in the country, and the largest in the world. It was built by Dorman Long & Co. and made of local steel. The bridge's lifting mechanism allowed large ships to pass up river when lifted, with the road providing a vital connection between Middlesbrough and the burgeoning chemical industry on the north bank of the River Tees. Following the Tees Newport Bridge Act 1989, which repealed the legal requirement to lift the bridge amidst the decline in large river traffic, the Tees (Newport) Bridge was last lifted on 18 November 1990.

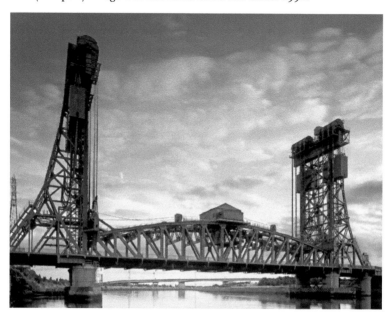

Transport

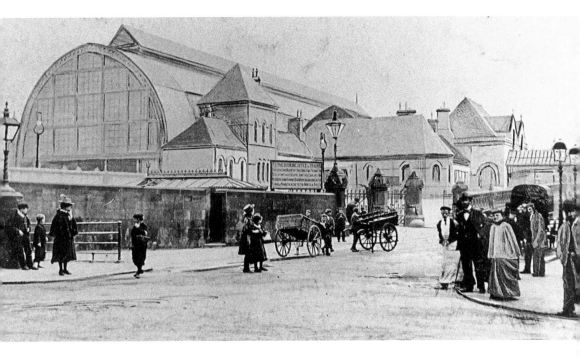

Middlesbrough Railway Station
Designed in 1877 by W. Peachy, architect, and W. J. Cudworth, engineer for the North Eastern Railway, the current railway station replaced the town's first station located next to Customs House.

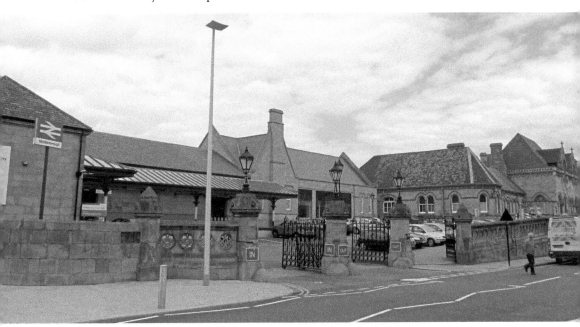

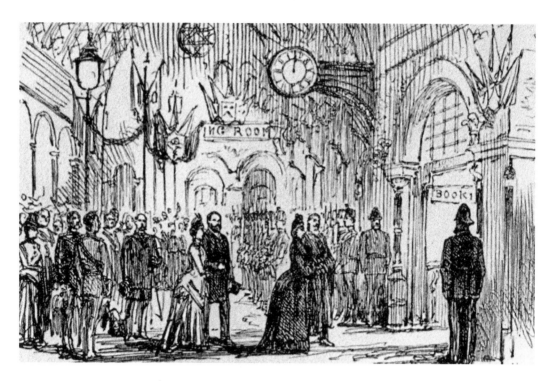

Middlesbrough Railway Station

Despite the various changes of routes, operators and trains over the years, a comparison of the modern photograph below with the artist sketch taken during the royal visit of 1889 reveals that the structure of the main hall has remained relatively untouched.

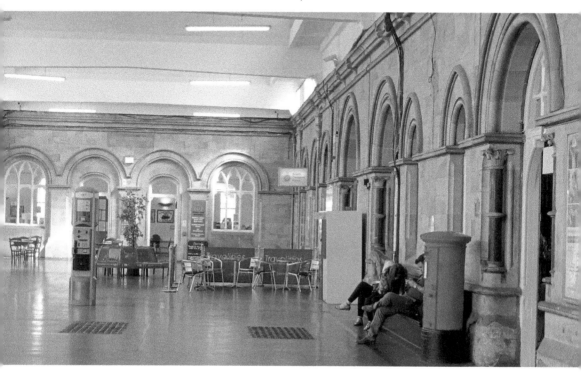

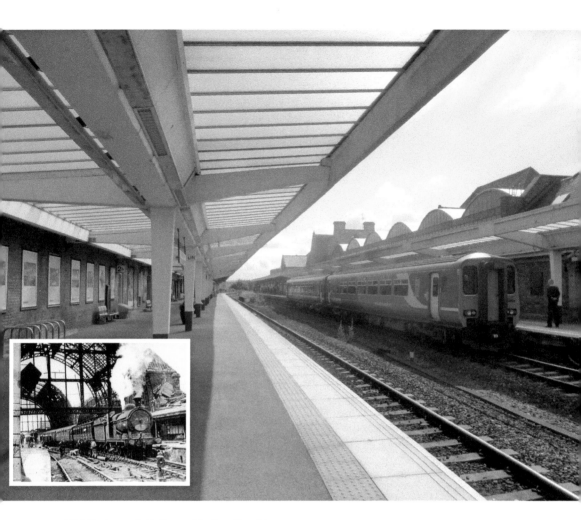

Middlesbrough Railway Station Bombing, 1942

The most notable change from the original building occurred as a result of enemy action during the Second World War. The bombing of August 1942 left several dead and nearby buildings damaged; the damage caused to the station's roof led to its eventual removal. Despite the significant bomb damage, trains were operational within a few days, as shown in the photograph inset.

Retail

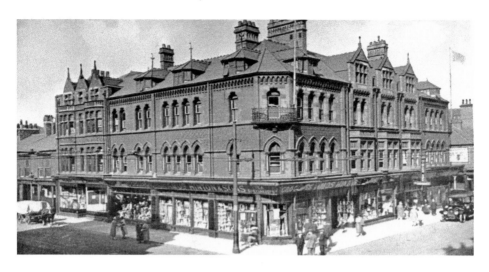

Hinton's

The grocery shop at the junction of Albert and Corporation Roads was once one of the many retail outlets of the Tring-born grocer, Amos Hinton. Having established his business in Middlesbrough in 1871, the premises shown here are now the home of the town's HSBC Bank. Above the store there was also a café, which for decades was a popular meeting place for the shoppers of Middlesbrough. As well as stores across Teesside, there were also stores in County Durham and North Yorkshire before the brand disappeared in 1984.

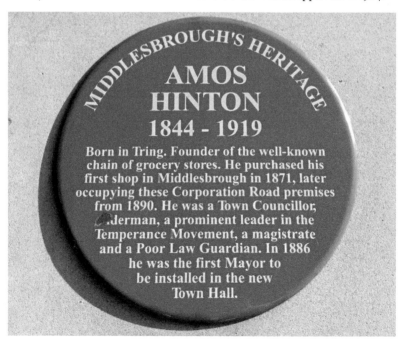

MIDDLESBROUGH'S HERITAGE

AMOS HINTON
1844 - 1919

Born in Tring. Founder of the well-known chain of grocery stores. He purchased his first shop in Middlesbrough in 1871, later occupying these Corporation Road premises from 1890. He was a Town Councillor, Alderman, a prominent leader in the Temperance Movement, a magistrate and a Poor Law Guardian. In 1886 he was the first Mayor to be installed in the new Town Hall.

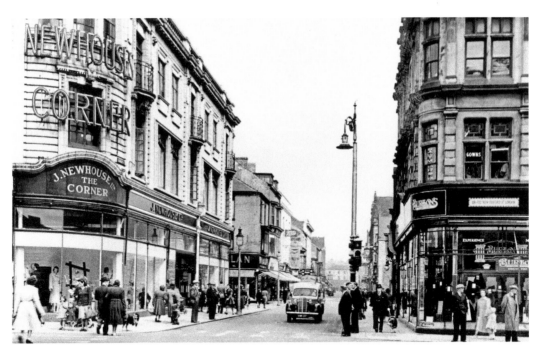

Newhouse's and Debenhams

A centrepiece of Middlesbrough's social history from the late nineteenth century onwards, the 1862 building first served as The King's Head public house, before being renovated and reopening as Newhouse's department store in 1912. The building is now a Debenhams department store and lies at the heart of the town's retail sector.

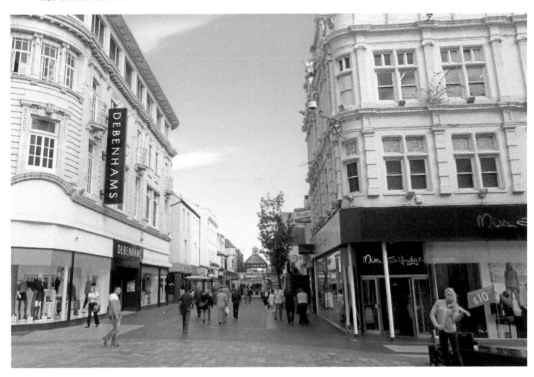

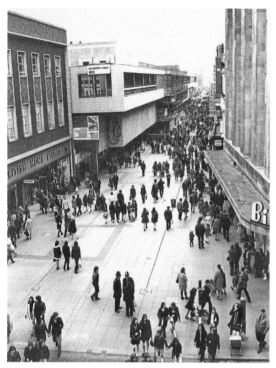

Binns and House of Fraser
Opened by Hugh Fraser in 1957, the grand building replaced Binns, which was destroyed when fire engulfed the four-storey department store in March 1942. A fashionable shopping location in Middlesbrough town centre, the shop has supplied the people of the town with attire ranging from miniskirts and flares to hoodies and onesies. Here the building can be seen on the right-hand side, with the more recent Cleveland Centre on the left of the photograph.

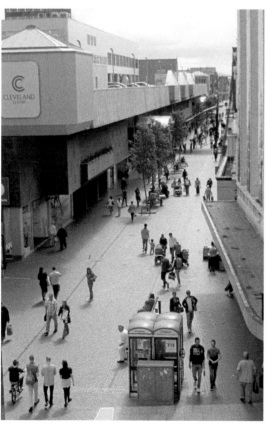

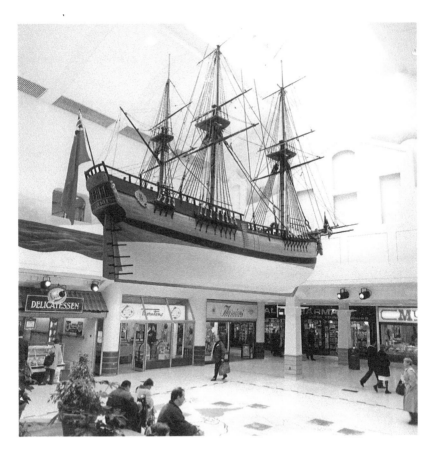

Cleveland Centre

Since opening in the 1970s, the Cleveland Centre has been one of the key retail locations in the town, providing a wide selection of retailers, restaurants and coffee shops. Having changed its name to The Mall, the Cleveland Centre brand was restored in 2012. A large replica model of Captain Cook's *Endeavour* once hung suspended from the ceiling of the Cleveland Centre until renovation work in the 1990s. The ship's former location is now occupied by the Endeavour Health Centre. The Centre was also once home to popular Teesside nightclub The Madison until its closure in the 1990s.

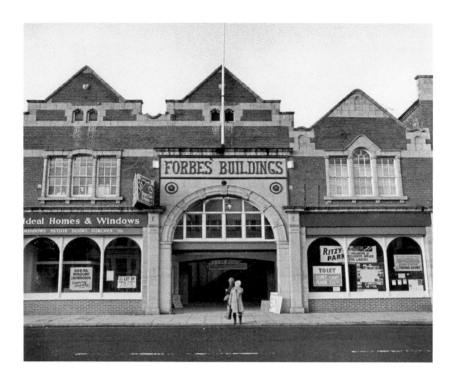

Forbes Buildings, Linthorpe Road

Located on Linthorpe Road, the buildings were built at the turn of the century as a bakery for John Forbes, former mayor of Middlesbrough. The buildings fell into disrepair in the 1970s but have since been revitalised and house a range of independent retailers, including a bookseller, coffee shop and hair stylists. Forbes Buildings also hold arts and crafts events on a regular basis.

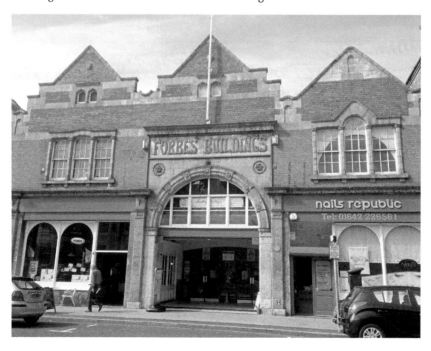

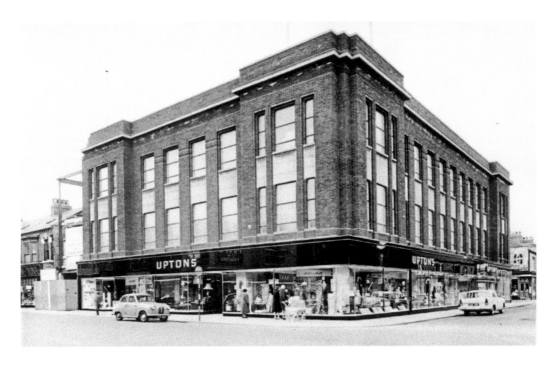

Upton's Department Store, Linthorpe Road

Shown here in the 1960s, Upton's Department Store was one of the premier shops in Middlesbrough, with the company serving the people of the area for over a century. The iconic Linthorpe Road store closed in 2001 but has enjoyed a new lease of life as the designer clothing department store Psyche. Operating on the site for over a decade, the multi-award-winning store has seen the building undergo extensive renovation work in recent years.

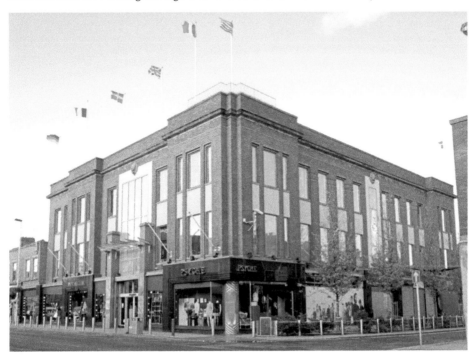

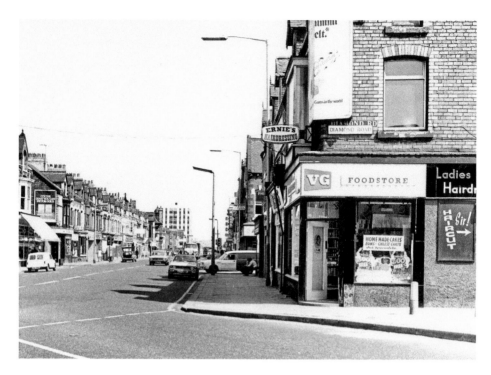

Borough Road

Home to Jack Hatfield Sports, the oldest sports shop in Middlesbrough and a legacy of the town's late swimming champion and Olympic medallist. Here the selection of fast-food premises can be seen from the 1970s compared with today's modern offerings, including Europa, the birthplace of the town's celebrated local cuisine the 'Parmo'!

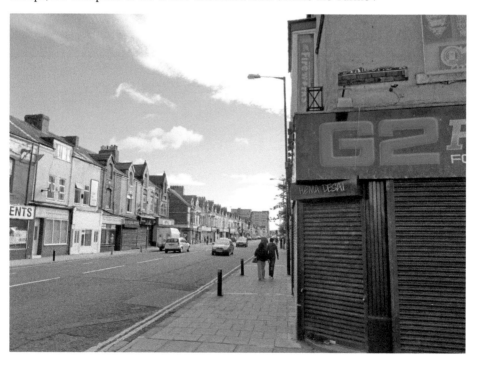

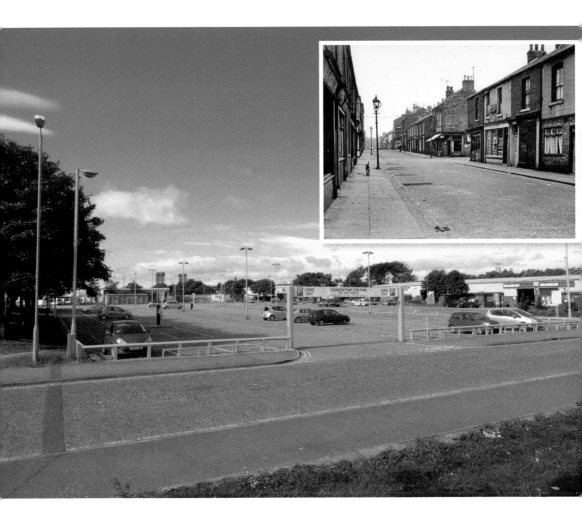

Cannon Street

The former Cannon Street area, mostly demolished in the 1960s and early 1970s, was one of the most populous parts of Middlesbrough and emerged as one of the key housing locations for workers in the nearby industries. Disturbances broke out in the areas in August 1961, partially as a result of racial tension in the area, and were dubbed the 'Cannon Street Riots', with hundreds taking to the streets. Much of the area is now covered by the Cannon Park development, consisting of retail outlets, warehouses and offices.

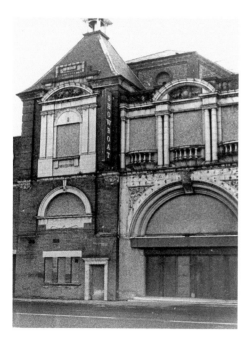
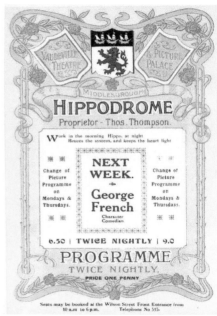

Wilson Street

Extensively damaged during the Second World War, Wilson Street was once a vibrant retailing part of Middlesbrough town centre. In close proximity to Middlesbrough railway station, the area was the site of the Hippodrome and the County Court. Both have in recent incarnations been the centre of Middlesbrough's nightlife as public houses and nightclubs. The area now backs onto the A66, which runs through the town.

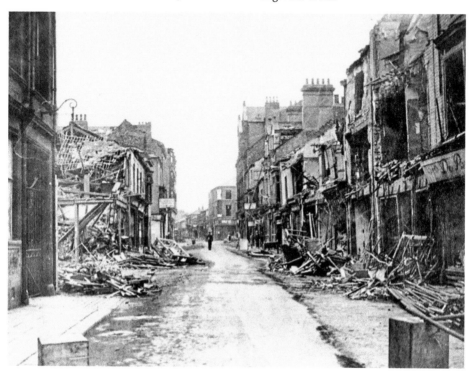

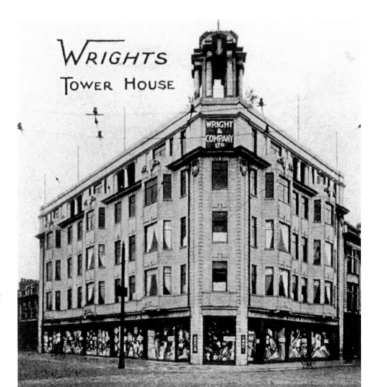

Wright's Tower House
The department store was a landmark building in Middlesbrough town centre for a number of decades, celebrating its fiftieth anniversary in 1960, having undergone considerable renovation a few years before. With the popularity of the store having diminished, the decision was made to close the store in 1983. The building was demolished in 1987 and replaced by a McDonald's fast-food restaurant, which still operates today.

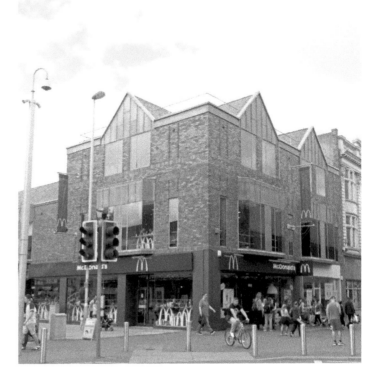

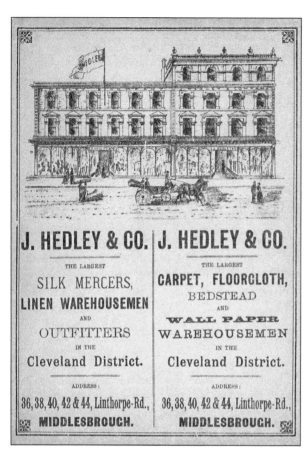

J. HEDLEY & CO.

THE LARGEST

SILK MERCERS,
LINEN WAREHOUSEMEN
AND
OUTFITTERS
IN THE
Cleveland District.

ADDRESS:

36, 38, 40, 42 & 44, Linthorpe-Rd.,
MIDDLESBROUGH.

J. HEDLEY & CO.

THE LARGEST

CARPET, FLOORCLOTH,
BEDSTEAD
AND
WALL PAPER
WAREHOUSEMEN
IN THE
Cleveland District.

ADDRESS:

36, 38, 40, 42 & 44, Linthorpe-Rd.,
MIDDLESBROUGH.

Linthorpe Road

The main road linking the town from north to south, with the affluent middle class taking up residence in Linthorpe Village and beyond as the town expanded southwards as industrialisation set in. Commerce has been a defining feature of the road, with everything from takeaways, hardware stores, restaurants, and even a bingo hall having all sprung up along the route over the decades. Few of the original retailers remain along the road, partially owing to the shopping centres in the town centre.

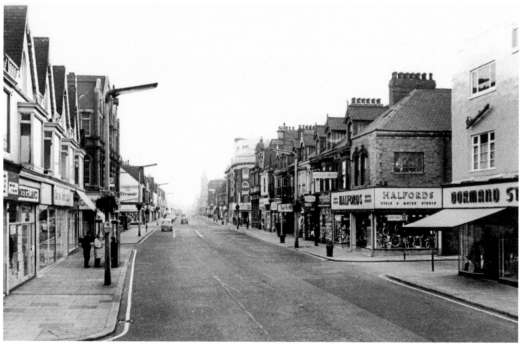

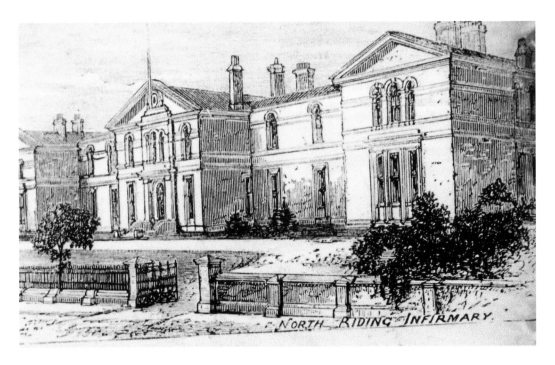

North Riding Infirmary

Opened on 5 June 1864 by Henry Bolckow, one of the hospital's chief benefactors, the North Riding Infirmary played a crucial role in treating injured workmen from the various iron and steel firms in the area. The ironmasters played a crucial role over several decades in the management and funding of the voluntary hospital, on occasion leading to conflict.

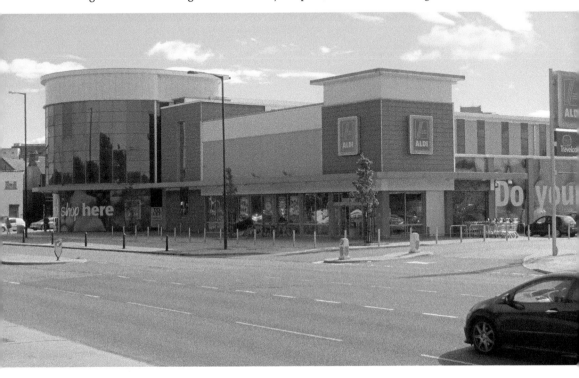

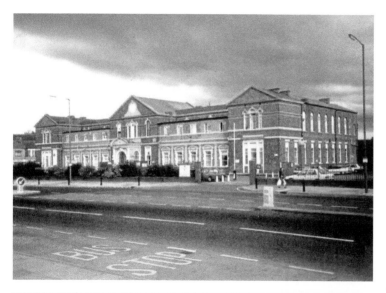

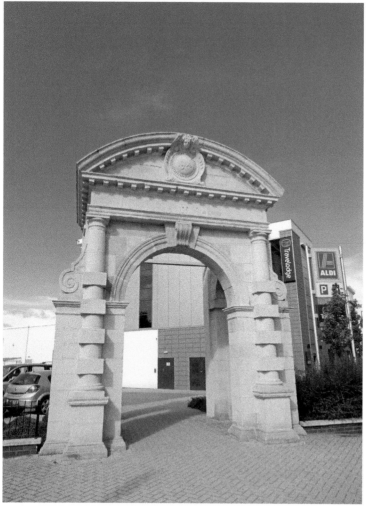

North Riding Infirmary
With the establishment of extended hospital provision in Middlesbrough at James Cook University Hospital, the North Riding Infirmary closed in 2003. The building was demolished in 2006, with only the arch shown here remaining. An Aldi supermarket and Travelodge now stand on the site.

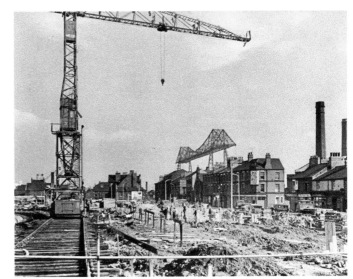

Durham Street

The St Hilda's and Middlehaven areas have undergone numerous changes over the decades, as is evident from this selection of photographs. On the main road leading northwards from the town to the Tees Transporter Bridge (visible in the top right of the photographs), trams and buses previously transported workers to and from the river crossing. Today the houses from the St Hilda's estate have been mostly cleared, although signs of regeneration are in evidence with the building of an urban park, seen on the right.

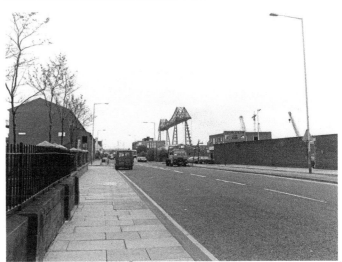

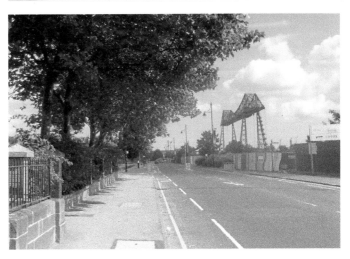

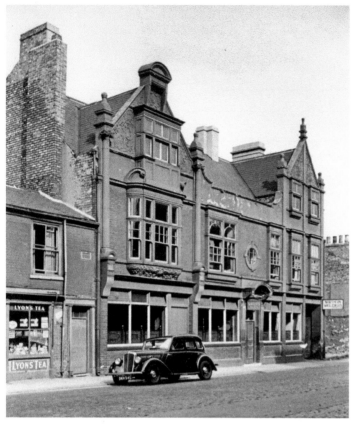

The Captain Cook

Opened around 1840, the Grade II listed former public house served the people of St Hilda's for some 170 years. The pub featured in the BBC series *Auf Wiedersehen, Pet* as the location for Oz's wake. However, owing to the declining population of St Hilda's and the closure of industry in the area, the number of people frequenting the pub declined and the decision was made to close in 2010. The building is now owned by Middlesbrough Council.

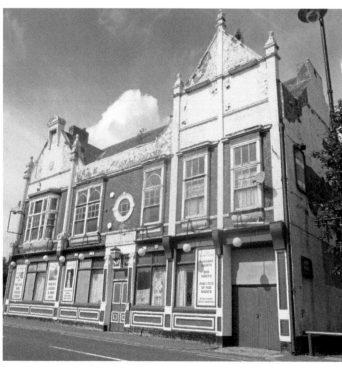

Dundas Street

Since opening as the Dundas Arcade in the 1970s, the Dundas Shopping Mall is situated adjacent to Linthorpe Road and the Cleveland Centre, forming the north-east quadrant of Middlesbrough's retail area. Here the approach to the shopping centre, which has since opening hosted an eclectic mix of retailers, reflects the shifting patterns of fashion and change and continuity on the high street, with Next having replaced C&A, but with the Early Learning Centre still in operation.

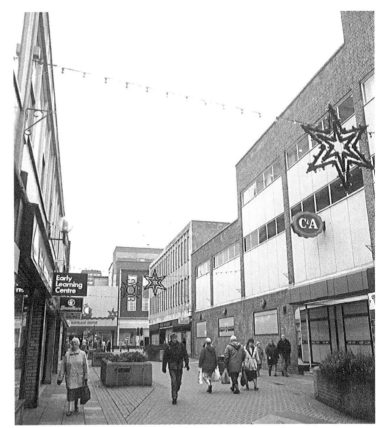

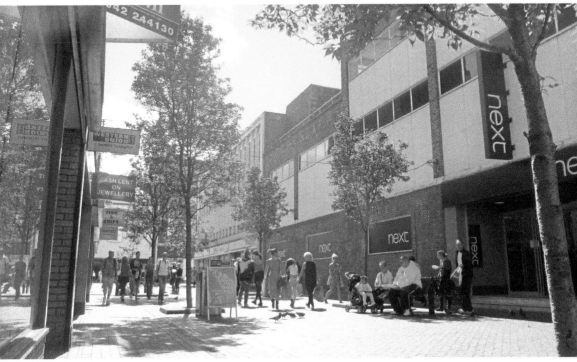

Cultural Buildings and Public Spaces

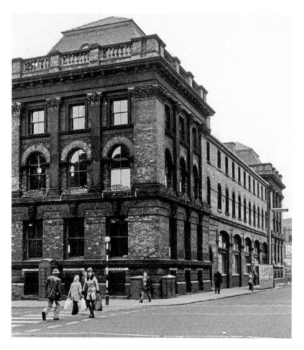

Exchange Square
Once the site of one of
Middlesbrough's grandest buildings,
the Royal Exchange, numerous
business organisations and banks
operated here when the area was the
town's financial and commercial hub.

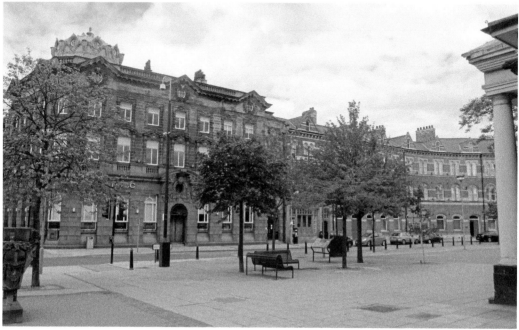

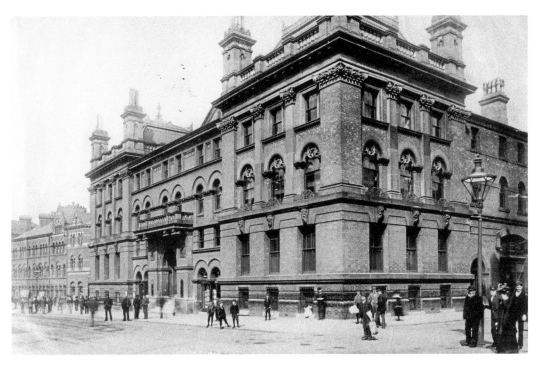

Royal Exchange

Designed by Charles John Adams and opened in 1868, the Royal Exchange provided offices for various business associations, steel firms, merchants and the Cleveland Club, prior to its move to the nearby former National Provincial Bank building. Despite it having been one of Middlesbrough's most grandiose buildings, the aged Royal Exchange was lost in the 1980s to the controversial construction of the A66 through the town. Only the ornamental carved heads remain and are exhibited around the square.

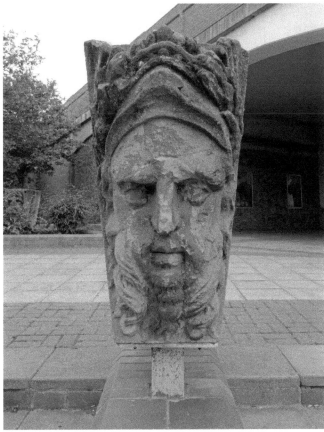

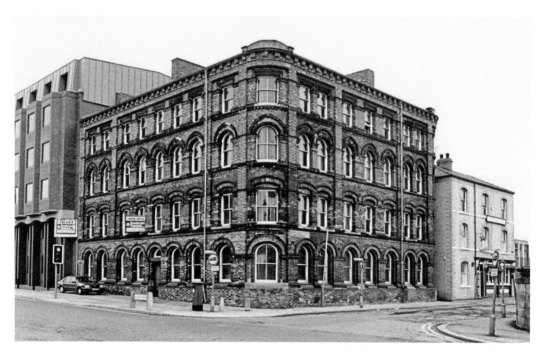

New Exchange Buildings

Situated on the corner of Bridge Street East, the Victorian office block was designed by architect W. H. Blessey in 1873. A variety of organisations have taken up residence there, including accountants, voluntary associations and agents.

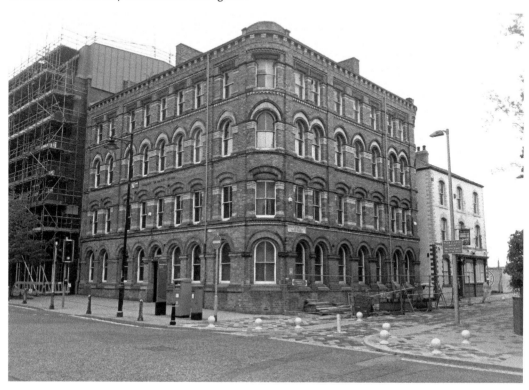

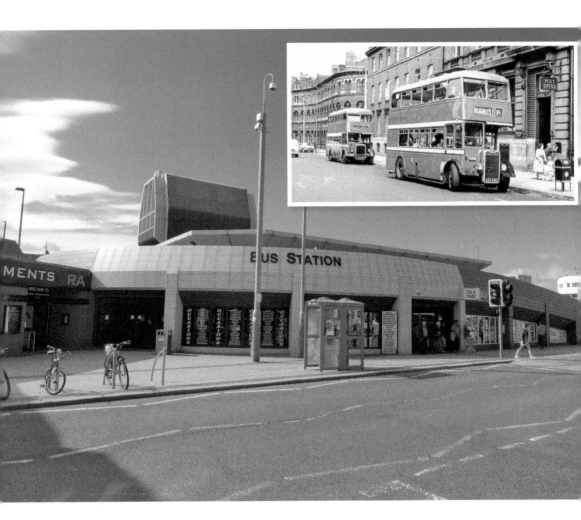

Exchange Square Bus Depot/New Bus Station

The Exchange Square later served as a bus transport hub before Middlesbrough Bus Station was constructed in the 1980s in closer proximity to the retailers in the town centre. There are now only limited transport links serving the area north of the railway line, although the recent Middlehaven regeneration has seen demand increase and new services commence.

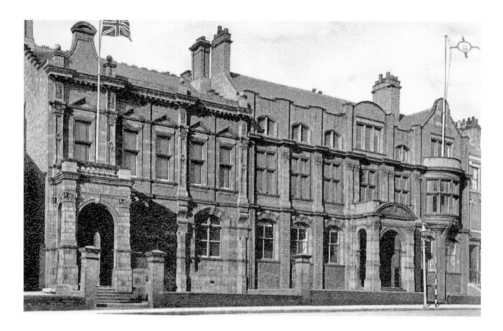

Port Authority Offices

Now the home of PD Ports, the Port Authority Offices were previously home to the Tees Conservancy Commissioners who were involved in the management of the River Tees, the original move to the buildings from their earlier headquarters in Stockton causing much controversy. The organisation played a vital role in the development of the river, facilitating efficient navigation and export of products from the manufacturing plants and factories along the Tees' banks.

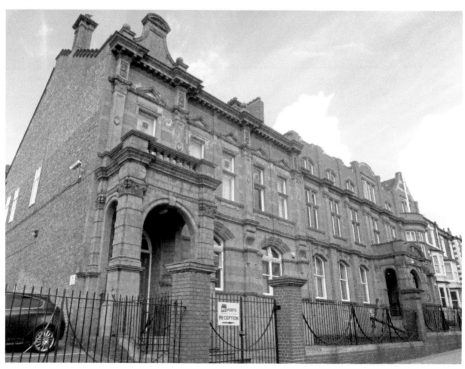

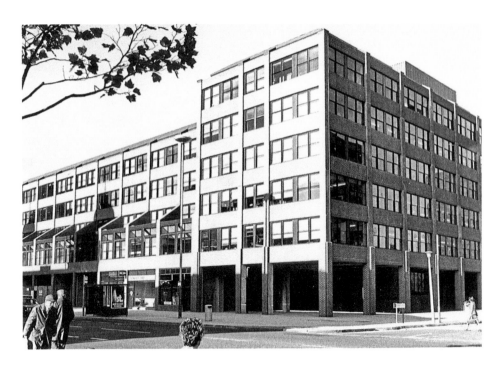

Vancouver House

Built in the late 1970s to relocate Middlesbrough Council staff from accommodation on Albert Road, the office block on the corner of Corporation Street and Gurney Street sits on the site of former town centre housing. Since opening, Vancouver House has been used by various departments of Middlesbrough Council. Little change has been made to the main structure of the building, although the shops and bar on the ground floor of Vancouver House have changed hands a number of times. The TS1 Gallery, showcasing local artwork, is currently housed in one of the units.

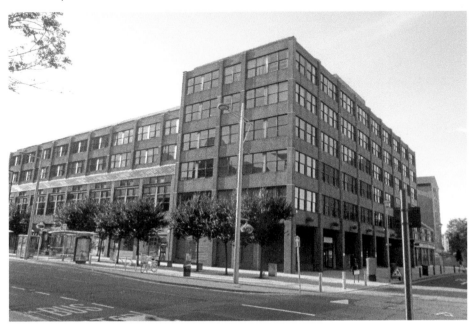

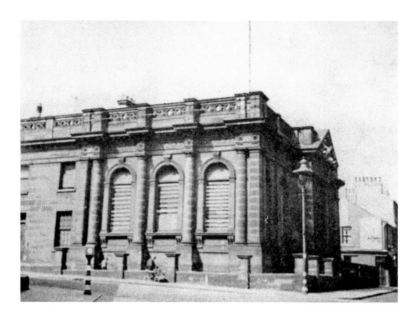

Cleveland Club
The current 1872 building, originally opened as the National Provincial Bank. The town's principal gentleman's club, the Cleveland Club, took up residence after the bank relocated to Albert Road in 1936. The club had previously been housed in the town's Exchange Building and attracted the town's chief businessmen and industrialists.

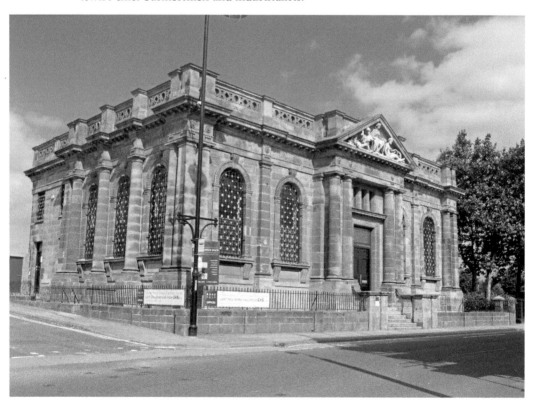

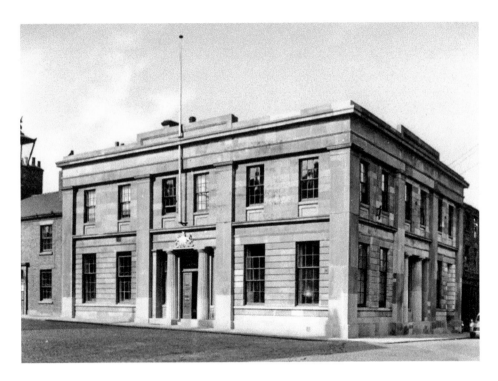

Customs House and Myplace

Completed in 1837, the Customs House was the host venue for the reception and banquet in honour of the visiting Duke of Sussex in October 1838, the town's first royal visit. The Grade II listed building operated as the public exchange rooms for merchants and businessmen in the early decades of Middlesbrough's industrial growth. However, the building proved too small for this purpose and the Middlesbrough Royal Exchange replaced it as the town's hub for commercial activity. The building is now the state-of-the-art, multimillion-pound youth complex MyPlace, opened in 2011.

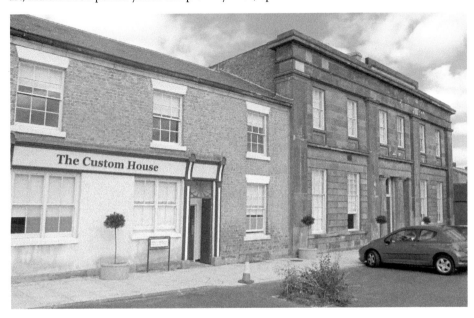

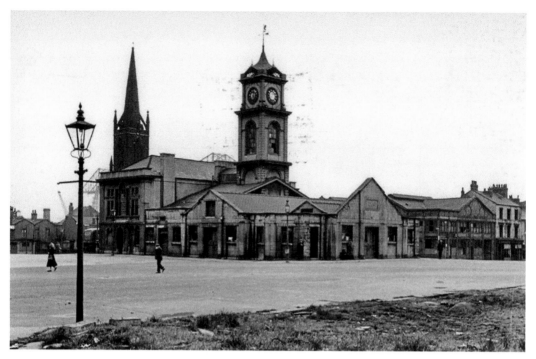

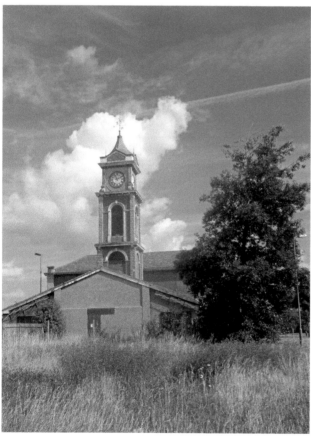

Old Town Hall

Built in 1846, the Old Town Hall was originally centred in the market place and housed the Middlesbrough Improvement Commissioners. However, as the town's municipal authority expanded following the Charter of Incorporation in 1853, Middlesbrough Town Council took up residence nearby before moving to a new town hall, which opened in 1889. The Old Town Hall has since operated as a community centre following renovation in the 1960s. However, in recent years the building has been vacant, although plans have been muted for redevelopment.

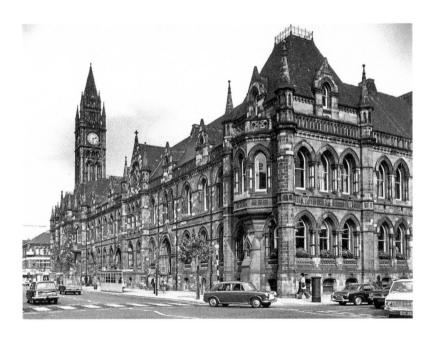

Town Hall, 1972 and 2013

The neo-Gothic Grade II* listed building is the centrepiece of Middlesbrough town centre. Officially opened on 23 January 1889 by the Prince and Princess of Wales and designed by Darlington architect G. G. Hoskins, the building boasts a striking clock tower that dominates the skyline. The Prince was presented with a key of gold and Cleveland steel as a memento of the occasion. The Princess set the town hall clock in motion by pressing an electric button, the first time that royalty had by the aid of electricity set a clock in motion.

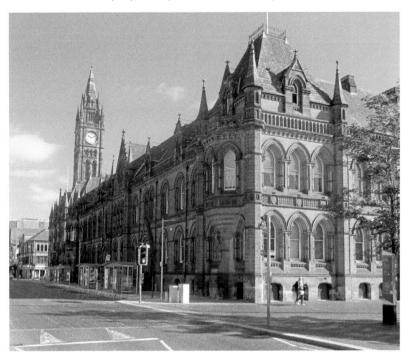

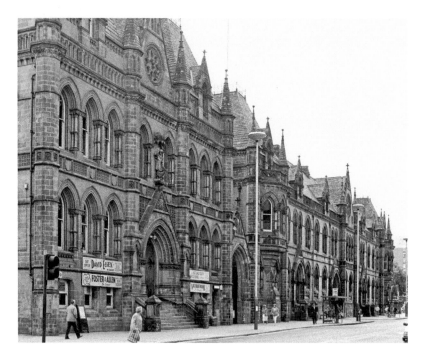

Town Hall, 1987 and 2013

The building continues to serve as home of Middlesbrough Council, while the town hall has also provided the venue for notable events and concerts in the town, ranging from hosting David Bowie in 1972 and Middlesbrough FC's promotion celebrations in the 1980s, to Teesside University graduations. The 1987 line-up shows David Essex, Foster & Allen, and Victoria Wood on the bill. More recent acts have included Jimmy Carr, Jools Holland and Morrissey.

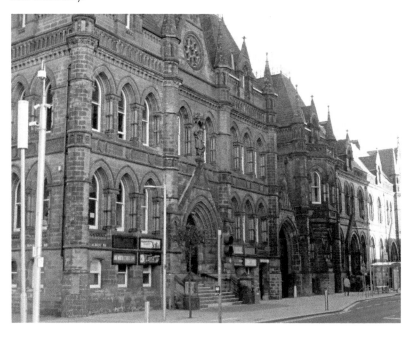

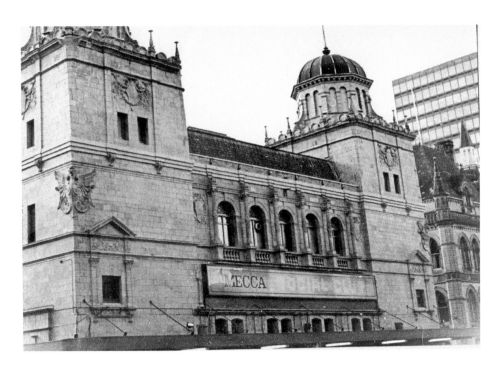

The Empire Theatre

Charlie Chaplin, Harry Houdini and Stanley Laurel all performed at the Empire Palace of Varieties in its heyday. Opened in 1899, the Empire had a seated capacity of 1,400 and was one of the major attractions in Middlesbrough. Having served as a bingo hall for almost thirty years, the Middlesbrough Empire is now one of the town's leading nightclubs.

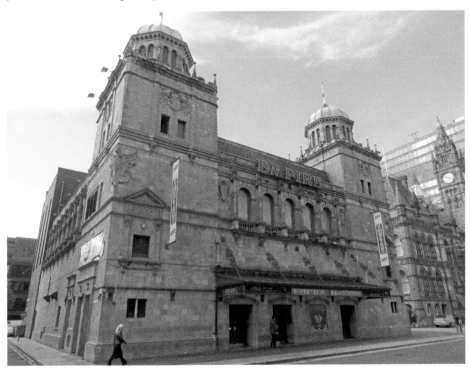

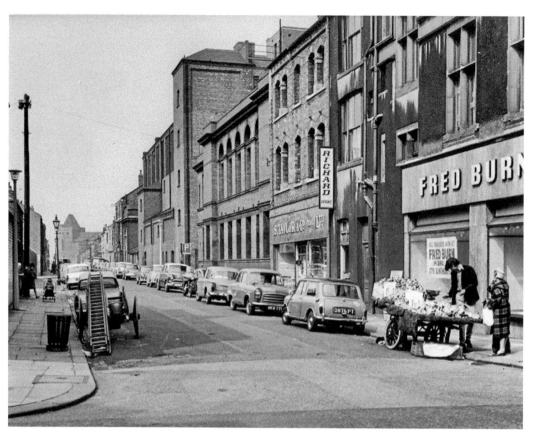

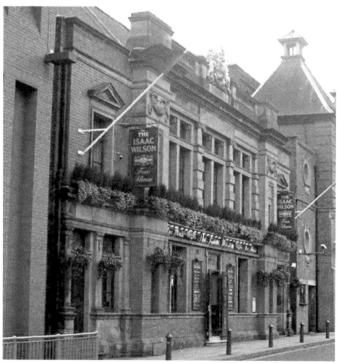

County Court and Isaac Wilson Public House
Originally built in 1901 as the county court, the building was the centrepiece of law and order in early twentieth-century Middlesbrough. Converted into a public house in the 1990s, the building now bears the name of the Victorian ironmaster and former MP and mayor of Middlesbrough, Isaac Wilson, a teetotaller.

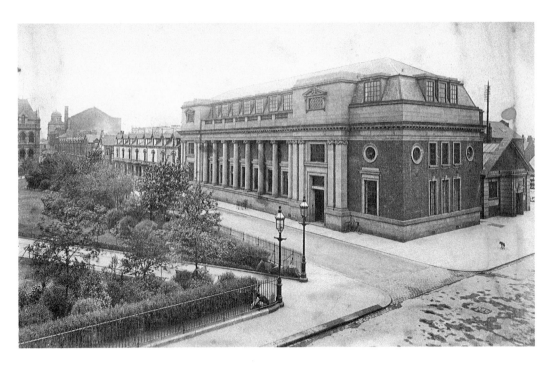

Middlesbrough Central Library

One of the thousands of libraries worldwide funded by the Scottish-American industrialist and philanthropist Andrew Carnegie, the library was opened by Aldermen Amos Hinton on 8 May 1912. Built on land donated by Hinton and local steel magnate Sir Hugh Bell, the building initially provided lending libraries where boys' and girls' sections were separated by a screen, with law, patents and reference libraries on the first floor.

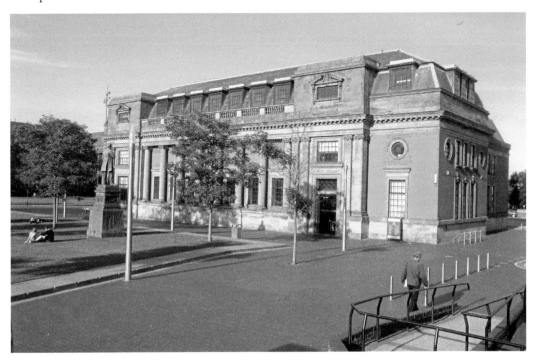

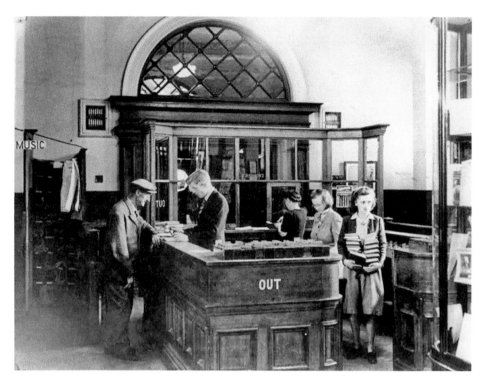

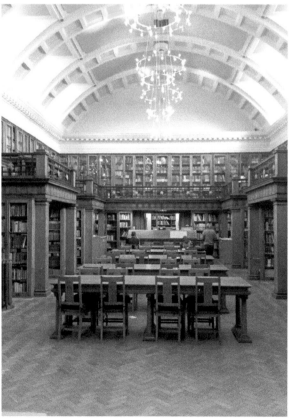

Middlesbrough Central Library

The library maintains many of its original features, including a comprehensive reference library, which houses an extensive collection of historical material on the town's history. In recent years theatrical performances, poetry recitals and live music have all been held at the library. Middlesbrough Central Library celebrated its centenary in 2012.

John Vaughan Statue

One half of the Bolckow Vaughan combine, which set in motion major iron manufacturing that led to the town's boom, John Vaughan moved to Middlesbrough having previously worked at Dowlais Ironworks in South Wales and Losh, Wilson & Bell in Walker-on-Tyne. He was mayor of Middlesbrough in 1855 and died in 1868. The statue was unveiled by Sir Joseph Pease on 2 June 1884 and, like that of his brother-in-law Henry Bolckow, has moved location several times. The statue currently stands outside the entrance to Middlesbrough Library.

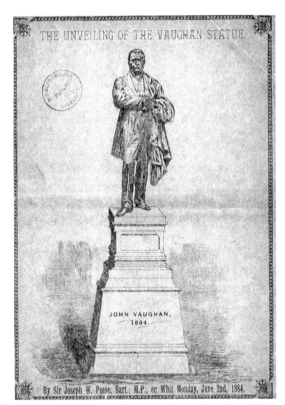

THE UNVEILING OF THE VAUGHAN STATUE.

JOHN VAUGHAN,
1884.

By Sir Joseph W. Pease, Bart., M.P., on Whit Monday, June 2nd, 1884.

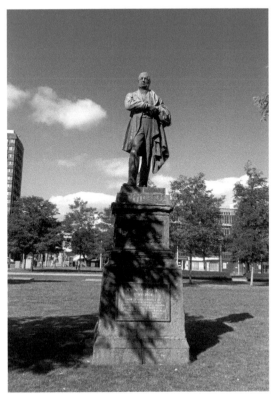

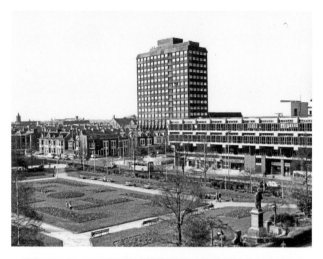

Victoria Square and Centre Square

Once dubbed Middlesbrough's 'dark continent', Centre Square continues to serve as a site for the citizens of Middlesbrough to gather. Flanked by Middlesbrough Town Hall, Middlesbrough Library, mima, registry offices, courts and *Bottle of Notes*, the open green space is the largest in Middlesbrough town centre and includes a water feature, table tennis courts and a large screen. Centre Square has also been a host venue for Middlesbrough Music Live and Mela festivals.

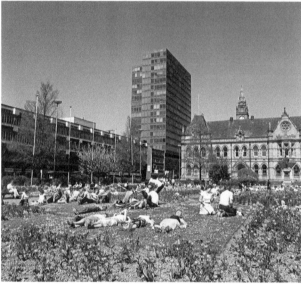

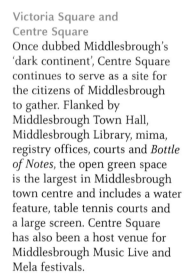

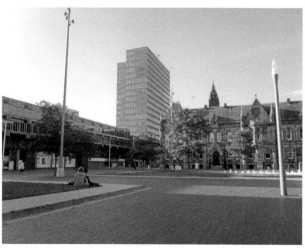

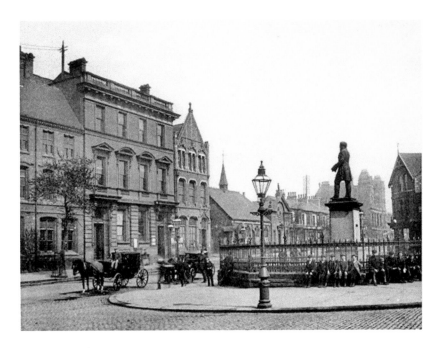

Teesside Archives

The home of the archival records of the area dating back to the twelfth century, the building was previously the town's head post office in the heart of Middlesbrough's business district. Many of the buildings in the area have been lost in recent decades, including the former offices of Jordison's printers. The building has been the home of Teesside Archives since the mid-1980s and houses an extensive collection of records relating to the town's iron and steel industries in the British Steel Collection.

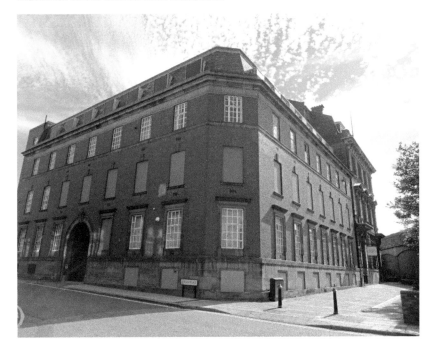

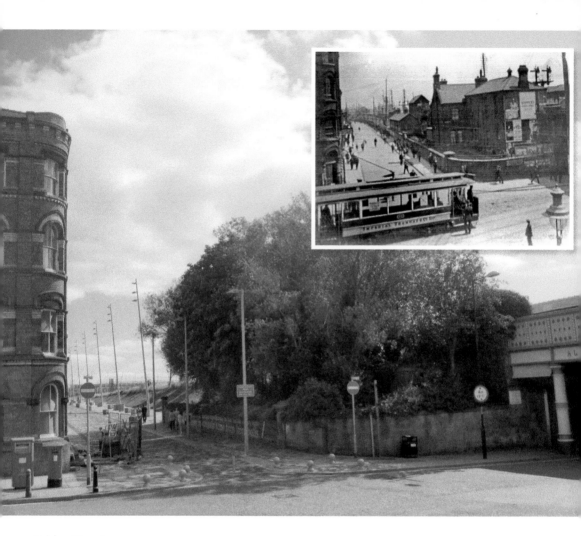

Bridge Street

A bustling hub of activity in the early twentieth century, Bridge Street can be seen in the old photograph with a tram service running down to the Tees Transporter Bridge. Workers at the iron and steel works and nearby dock can also be seen. In recent years, with the area having fallen into decline as manufacturing demised and Middlesbrough Dock closed, extensive regeneration has taken place, with long abandoned public houses reopening and new buildings emerging along Bridge Street.

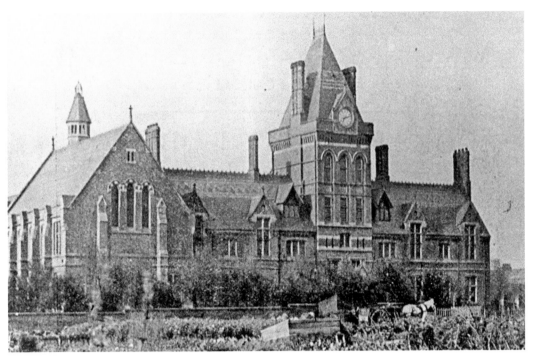

Middlesbrough High School

With its landmark clock tower that still stands as part of Teesside University, the building was designed by Alfred Waterhouse in the Gothic style and opened in 1877. The buildings replaced smaller provision provided for the town's boys and girls earlier that decade on Grange Road, with the town's industrialists playing a key role in the development of education provision.

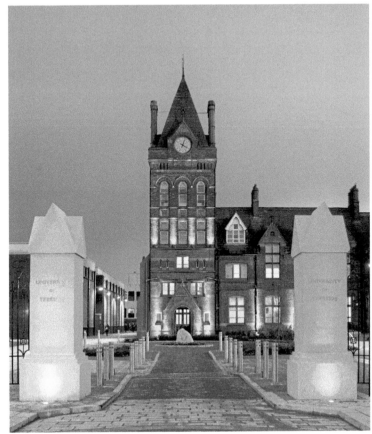

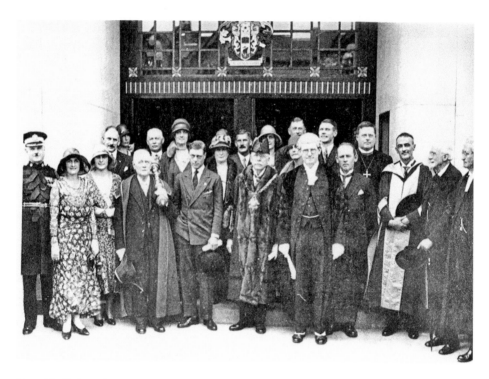

Teesside University

Opened as Constantine Technical College on 2 July 1930 by HRH the Prince of Wales, the white stone building is now part of Teesside University. Funded chiefly by the late Joseph Constantine, the college provided extended provision in technical education with departments in metallurgy, engineering, arts and crafts, and building trades. The university is now one of the country's leading universities, and was named *The Times* Higher Education University of the Year 2009.

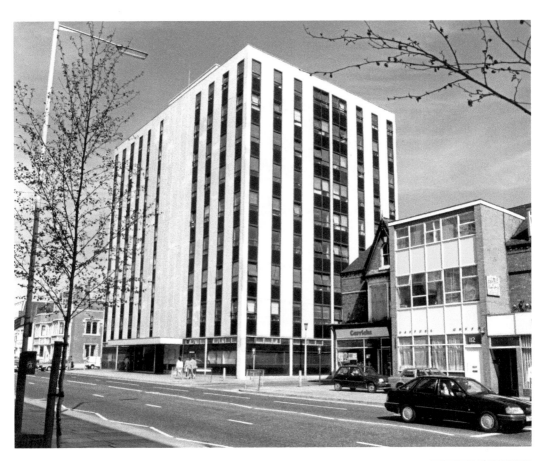

Teesside House

Reflecting Teesside University's growth in recent years, Teesside House student accommodation complex has been built in the last decade in place of former offices. Situated on Borough Road, the towering building sits adjacent to the Constantine Building, formerly Constantine College. Here the former offices on the site can be seen, contrasted with the new modern accommodation.

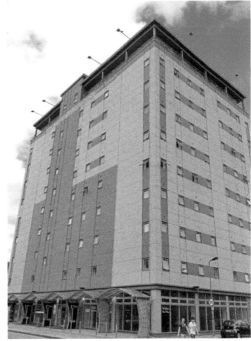

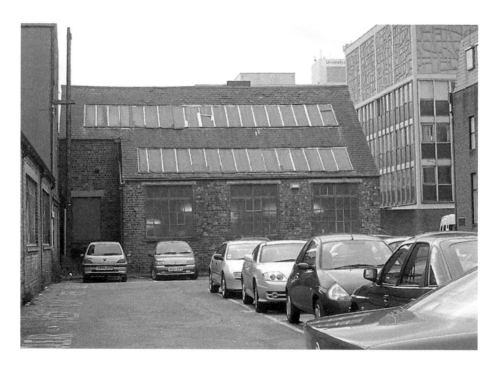

Middlesbrough Institute of Modern Art

Costing over £14 million to build, Middlesbrough Institute of Modern Art (mima) opened in the shadow of the town hall and central library in January 2007. One of the leading modern and contemporary art and craft galleries in the United Kingdom, mima has hosted works including those of Pablo Picasso, Andy Warhol and Damien Hirst. The building has also won several architectural awards and sits overlooking the town's Centre Square on a site formerly occupied by housing.

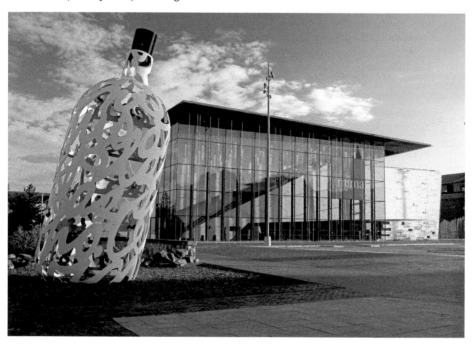

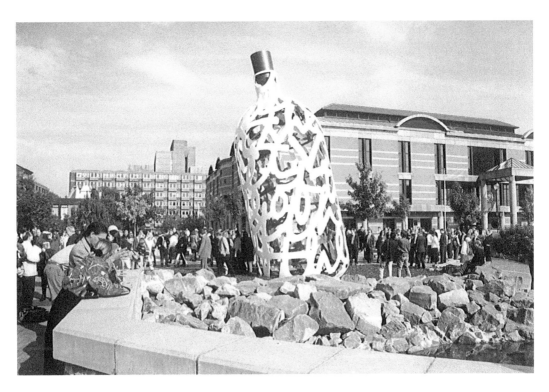

Bottle of Notes

Featuring the words from the log of Captain James Cook, born in nearby Marton and one of the leading discoverers of the eighteenth century, *Bottle of Notes* was commissioned by Middlesbrough Council in the 1980s and made from local steel.

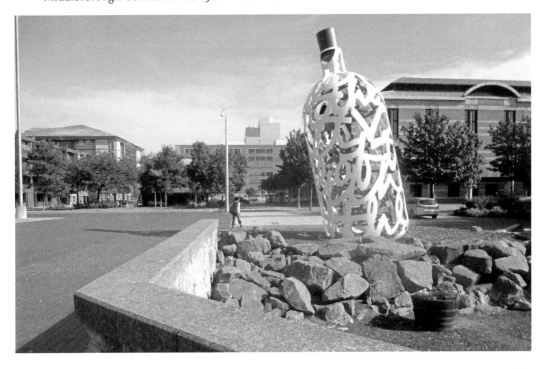

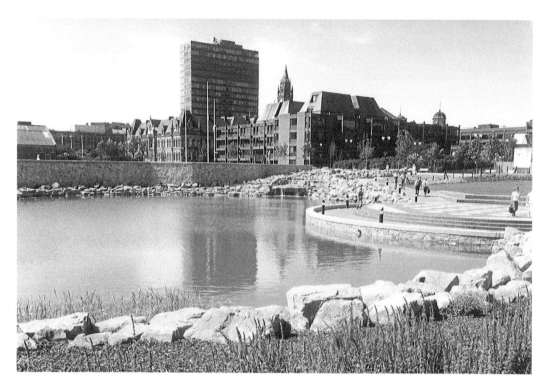

Bottle of Notes
Designed by Claes Oldenburg and Coosje van Bruggen, the sculpture was unveiled by Lord Palumbo in September 1993. The **Bottle of Notes** marked its 20th anniversary with a special celebration with mima, in front of which the sculpture sits in Middlesbrough's Centre Square.

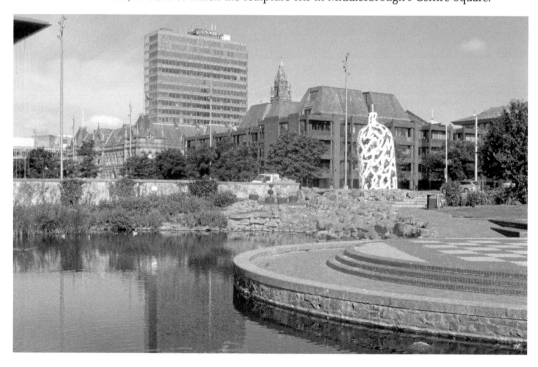

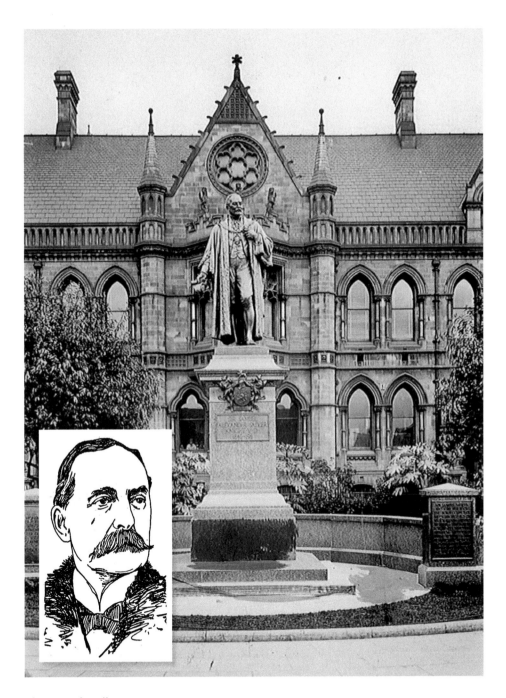

Sir Samuel Sadler Statue

Sadler was a prominent member of the Middlesbrough community and was the town's first Conservative MP. 'The Colonel', as he was affectionately known for his role as leader of several volunteer battalions of the Durham Light Infantry, died in 1911, having stepped down as mayor due to ill health a few weeks before his death.

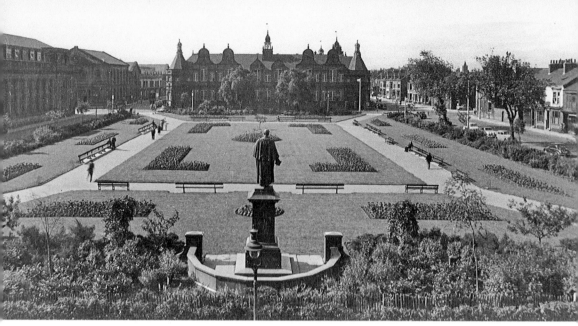

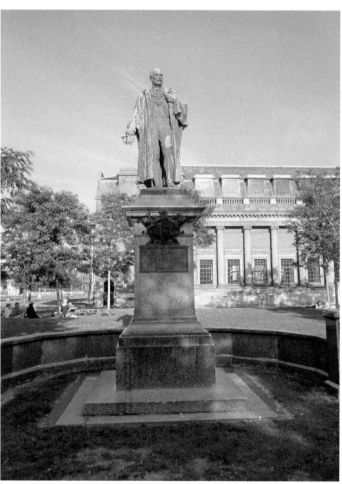

Sir Samuel Sadler Statue

Erected in Victoria Square (now Centre Square) following a public appeal to commemorate the town's late chemical manufacturer, the statue was unveiled on 21 June 1913 by Colonel John E. B. Seely. The statue has moved from its original site (shown here looking over Victoria Square towards Hugh Bell School) in recent years as a result of the renovation of Centre Square.

Odeon Cinema

Formerly the site of the Odeon cinema, the area is now cleared and operates as a car park. Jumpin' Jaks nightclub operated on the site for several years before the building was eventually demolished. This photograph from 2000 shows *Stuart Little* and *Perfect Storm* among the screenings. Town centre cinema-goers are now catered for by the nearby Cineworld complex.

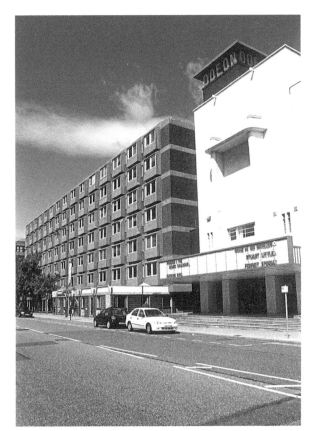

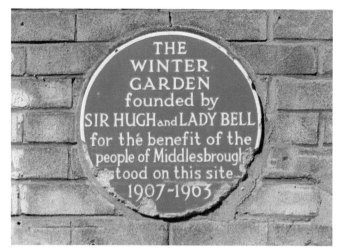

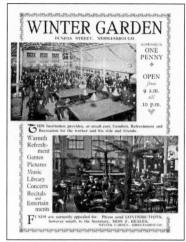

Middlesbrough Winter Garden

Established by Lady Florence Bell, wife of Middlesbrough steel magnate Sir Hugh Bell, the Winter Garden opened as a teetotal leisure facility for the workmen of Middlesbrough and their families. Eight cottages in Dundas Street and Dundas Mews were demolished to make way for the Winter Garden. The venue opened on 24 October 1907, with admission at one penny and brass band entertainment provided along with dominoes, darts and a billiards table.

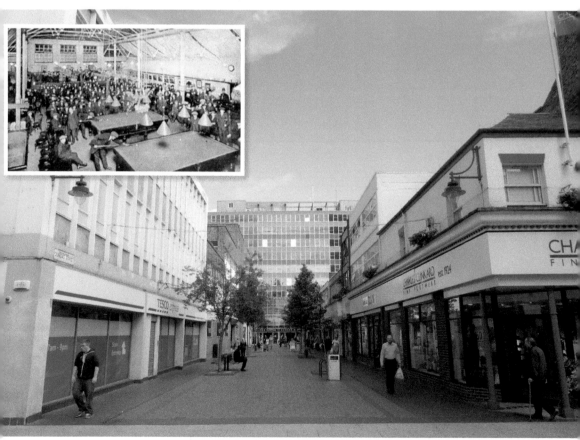

Gilkes Street Swimming Baths

Jack Hadfield, a medallist at the Stockholm Olympics in 1912, learned to swim at the baths as a youngster. As well as providing swimming facilities, the slipper baths also fulfilled a vital function in providing cleaning facilities when baths were not a common feature of the town's working-class housing. The baths have now been demolished and replaced by Captain Cook Square retail complex, which houses a range of bookshops, clothing outlets and general retailers.

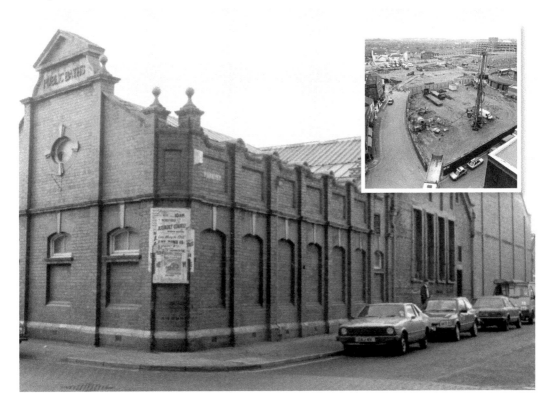

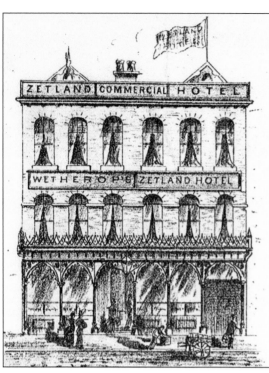

ROBᵀ· WETHEROP,

"Zetland Hotel,"

ZETLAND ROAD,

MIDDLESBROUGH.

WINES ❧ AND ❧ SPIRITS

Of the best quality.

CHOICE CIGARS.

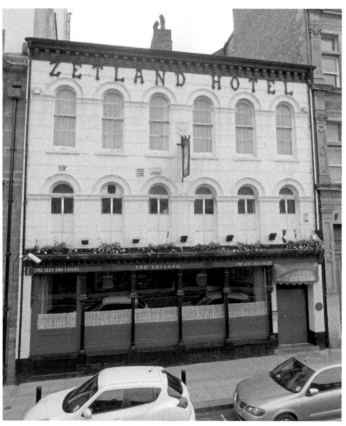

The Zetland Hotel
The Grade II listed building, dating from around the 1860s, has been a watering hole for the people of the town for over a century. The Zetland Hotel's proximity to Middlesbrough railway station has made it a popular location with commuters. The late nineteenth-century extension of the public house to the rear of the building features extensive tile work and rounded mirrors. The sketch above shows the hotel as advertised in the commemorative programme for the unveiling of the John Vaughan statue in 1884.

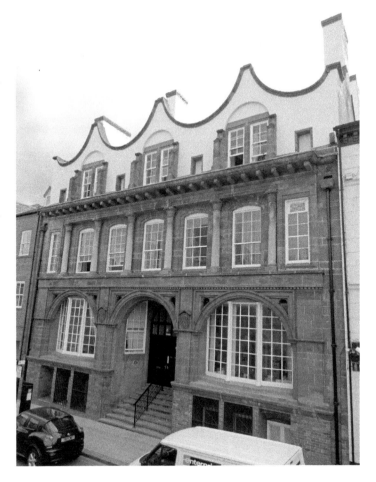

Webb House

Designed by the father of the Arts and Crafts Movement, Philip Webb, the premises were built for Bell Brothers and later provided the offices for its associated firm Dorman Long. Webb House is arguably the most architecturally significant building in the town. This building was the only commercial undertaking by Philip Webb, who was a friend of Sir Hugh Bell. A bell was fitted in the building to announce the arrival of Sir Hugh Bell's train back to his home, which first was at Red Barns in Redcar and later Rounton Grange near Northallerton – both of which Webb worked on extensively.

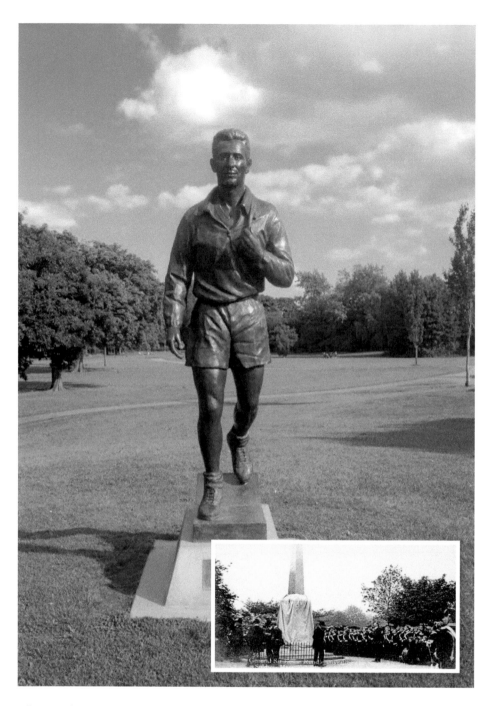

Albert Park

Donated to the people of Middlesbrough by ironmaster and MP Henry Bolckow, Albert Park was opened in 1868 and was an early home of Middlesbrough FC. Notable features include a fountain donated by Joseph Pease, a South African (Boer) war memorial, clock tower, lakes and sculptures. In recent years, a statue of the late Middlesbrough-born Brian Clough has been erected. Clough would walk through the park en route from his home in Grove Hill to his hometown club's Ayresome Park.

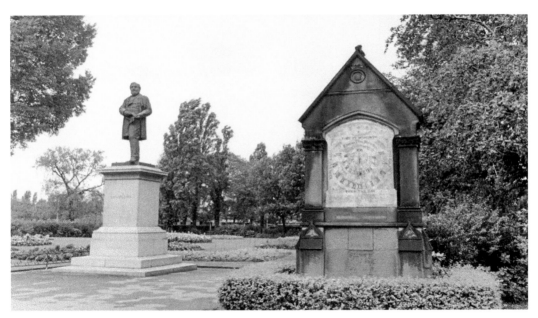

Henry Bolckow Statue

Designed by D. W. Stevenson, the statue's unveiling by Lord Cavendish formed the centrepiece of Middlesbrough's fiftieth anniversary Jubilee celebrations on 6 October 1881, delayed by a year due to economic hardship in the town. People from all walks of life turned out for the unveiling of this tribute to Henry William Ferdinand Bolckow, the first mayor and MP for Middlesbrough who had passed away in 1878. The statue has been moved several times, including a stint in Albert Park (*above*).

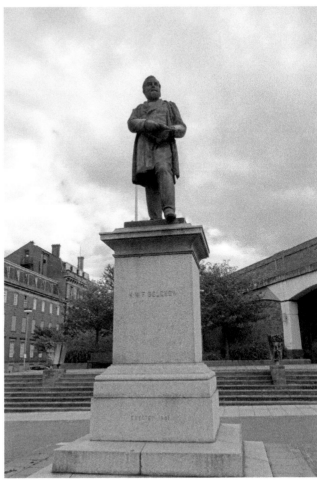

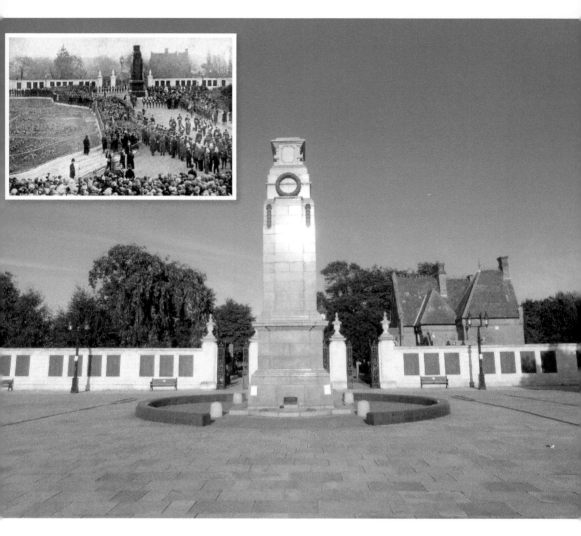

Albert Park – Cenotaph

Unveiled in November 1922, the 34-foot-high, Aberdeen granite cenotaph stands outside the gates of Albert Park, and was initially constructed as a memorial to those from Middlesbrough who lost their lives during the First World War. Those who died in later wars have been added over the decades, while there is a memorial wall adjacent lining the entrance to the park.

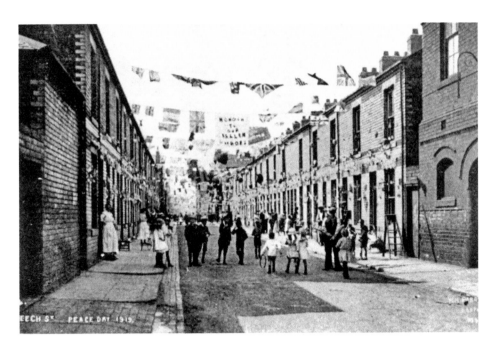

Beech Street

A thriving housing estate that emerged to house the iron and steel workers flocking to Middlesbrough during the town's industrial heyday, the houses have now been demolished and the offices of HM Customs and Excise now occupy part of the site.

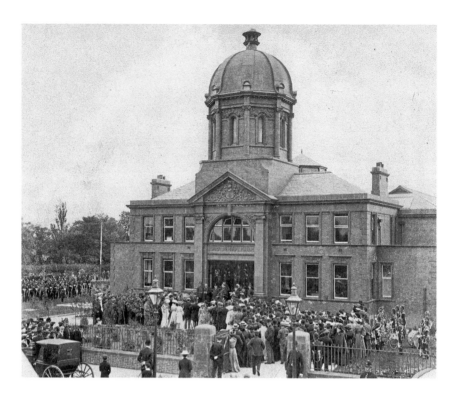

Dorman Memorial Museum

Donated to the town by Arthur J. Dorman in memory of his son George Lockwood
Dorman, who died during the Boer War, the museum opened on 1 July 1904 as
a natural history museum, and has served as the town's main museum for over a
century. The galleries chart the development of the town and industry in the area,
and have an extensive collection of bird samples from across the globe, as well as
one of the largest collections of Christopher Dresser pottery in the world.

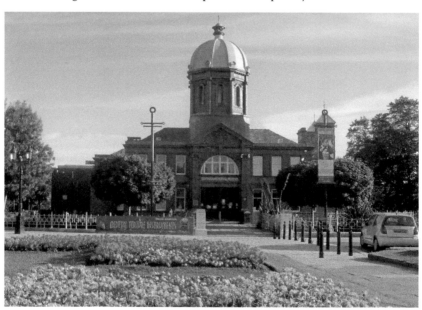

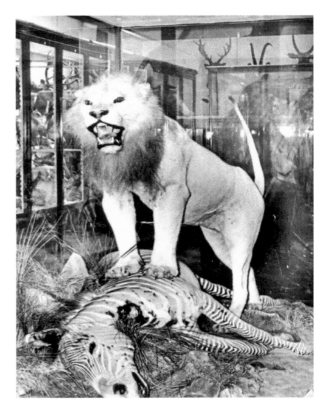

Dorman Memorial Museum
One of the most popular attractions at the museum for decades has been that of a lion eating a zebra, shown here. As well as many items dating back to well before the museum's foundation, the galleries also provide temporary space for many art exhibitions.

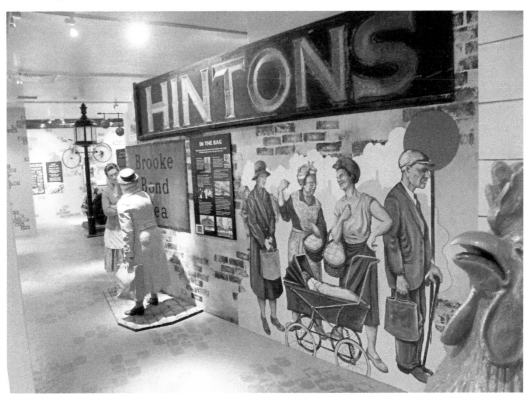

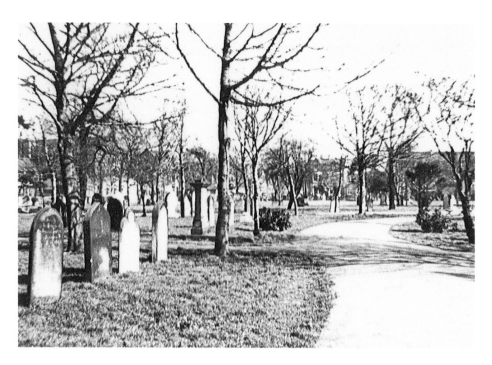

Ayresome Gardens

Situated off Linthorpe Road, this small urban park and playground was previously the site of Ayresome Cemetery until it was decommissioned in the 1960s. The gardens can be seen here in their cemetery form and during the 1966 World Cup, with nearby Ayresome Park having been a host venue for the tournament, most famously staging North Korea's 1-0 win over Italy. The site was often used as a shortcut to Ayresome Park for fans travelling to Middlesbrough FC's home games. The small urban park now contains play and exercise areas.

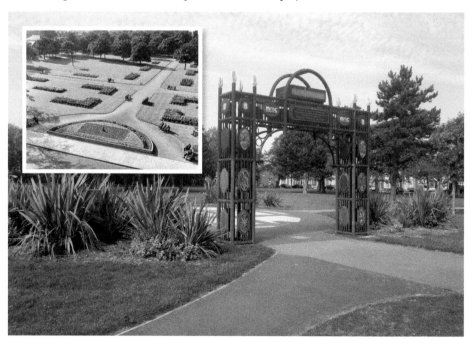

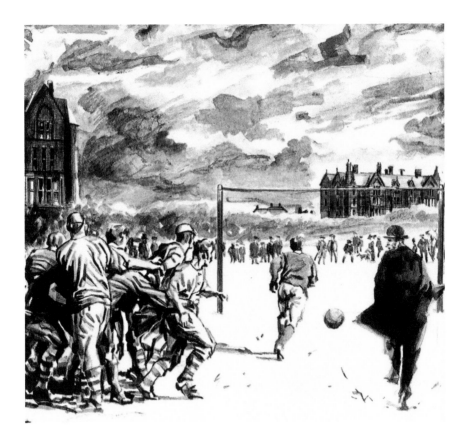

Middlesbrough Football Club

Established in 1876, the Boro played at numerous grounds in their early days, including the Archery Ground, Breckon Hill and Linthorpe Road. Turning professional led to the formation of Ironopolis as a short-lived breakaway club. Middlesbrough reverted to amateur status, winning the FA Amateur Cup twice before returning to professional status in 1899. The early Archery and Linthorpe Road grounds are illustrated here by Richard Piers Rayner, a celebrated, locally born illustrator for DC and Marvel Comics and artist-in-residence at Middlesbrough FC.

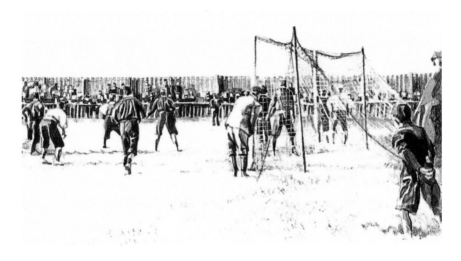

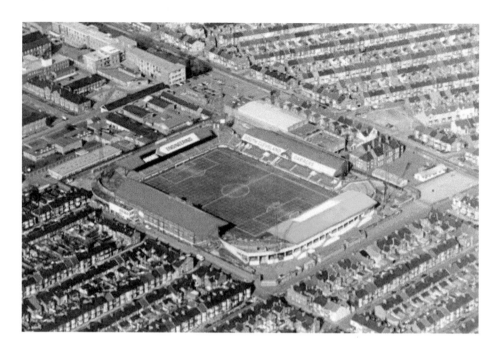

Ayresome Park

In 1903, Middlesbrough FC moved to Ayresome Park, which would go on to be a host venue for the 1966 World Cup. Throughout the decades numerous greats have worn the club's famous red shirt, from Alf Common (bought for a world-record £1,000 in 1905), local heroes Wilf Mannion and George Hardwick either side of the Second World War, through to promotion stars of the 1990s such as Steve Pears and Paul Wilkinson. The final league match at the famous old ground took place on 30 April 1995, with Middlesbrough beating Luton Town 2-1, with a brace from John Hendrie.

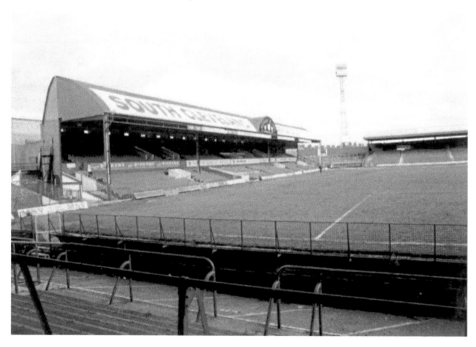

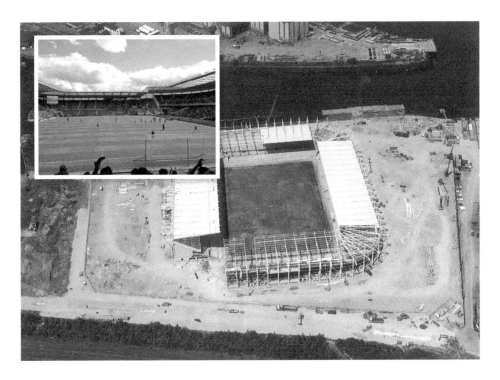

Riverside Stadium

Middlesbrough FC opened their account at the new, 30,000 all-seater stadium on the banks of the River Tees with a 2-0 win against Chelsea on 26 August 1995. The Riverside has since hosted full England football international matches, and was the first stadium to stage Team GB football matches prior to the London 2012 Olympic Games. Following the club's first major trophy success after beating Bolton Wanderers 2-1 in the 2004 League Cup final, the Riverside played host to UEFA Cup matches featuring some of European football's greatest teams.

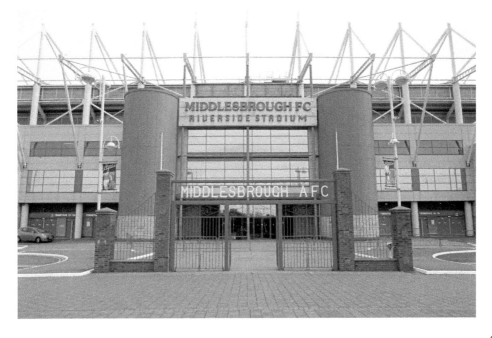

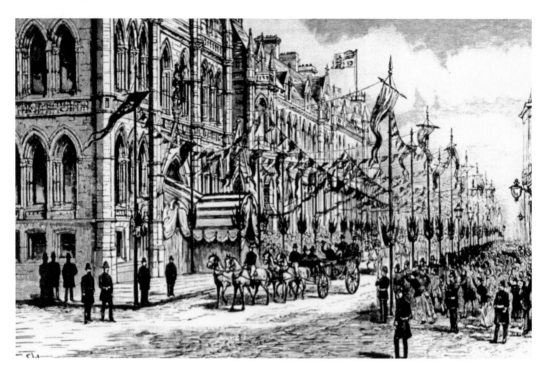

Albert Road and Corporation Road Junction

Albert Road has provided the main link through the centre of town for over a century. The sketch shows the Royal Procession at the opening of the new town hall in 1889, with the early twentieth-century photograph showing one of town's trams passing a crowded centre. The electric trams were introduced in the 1890s, replacing the early horse-drawn trams.

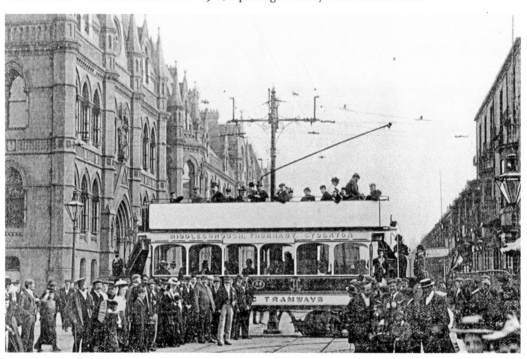

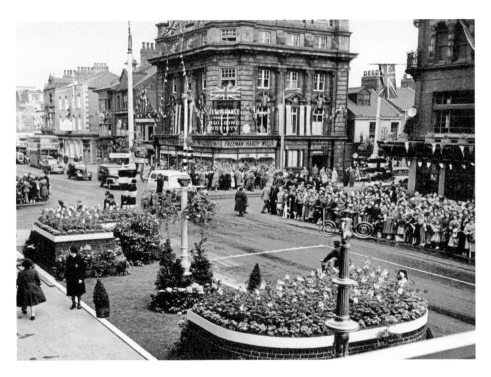

Albert Road, Corporation Road Junction, 1956 and 2013

The visit of Queen Elizabeth II saw thousands throng the streets of Middlesbrough in June 1956. The crowds can be seen gathered at the junction of Albert Road and Corporation Road, with the Temperance Permanent Building Society, the site of the current Darlington Building Society, visible on the corner.

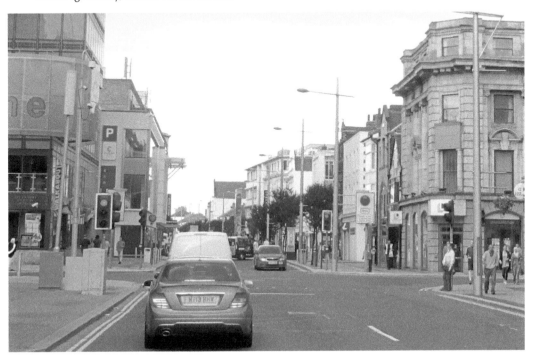

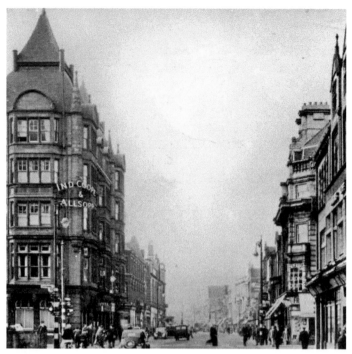

Corporation Hotel
Birthplace of late *Eastenders* star Wendy Richards, the Corporation Hotel can be seen on the left in the 1930s. Students from the nearby Middlesbrough High School and Constantine College would frequent the bar. The building was demolished as part of town centre renovation and Centre North East now stands on the site.

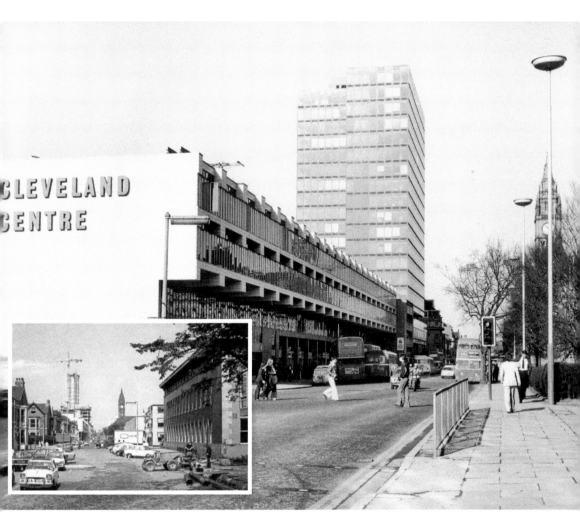

Centre North East

Completed in 1974 and towering 70 metres above the town's skyline on the corner of Albert Road and Corporation Road, Centre North East is the tallest building in Middlesbrough. Previously known as Corporation House, built on the site of the former Corporation Hotel, the building chiefly operates as office and call centre space. The ground floor is home to Blu Bar and Walkabout nightclubs, having previously been the premises of a high street bank.

Churches

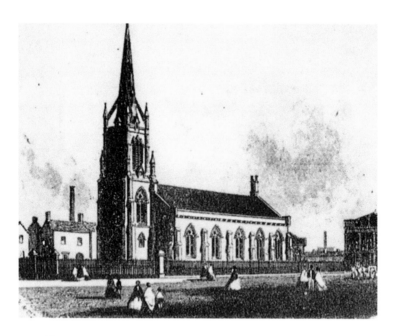

St Hilda's Church and Market Place
St Hilda's church was opened in 1840 and consecrated by the Bishop of Durham Edward Maltby. The church was situated in the St Hilda's area of Middlesbrough, in close proximity to the Old Town Hall and Customs House. The church's tower can be seen here in the post-war period. One of the grandest buildings in Victorian Middlesbrough, St Hilda's, featured in L. S. Lowry's *The Old Town Hall and St Hilda's Church* (1959).

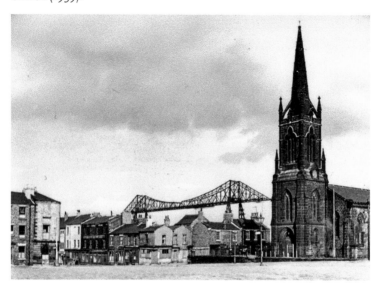

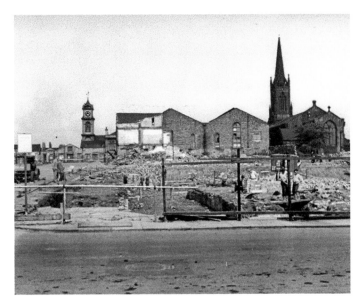

St Hilda's Church Bells
The church was demolished in 1969 as part of wider renovation in St Hilda's. The church bells, donated to St Hilda's by leading Victorian citizens of Middlesbrough, have been relocated to Middlesbrough town centre off Linthorpe Road.

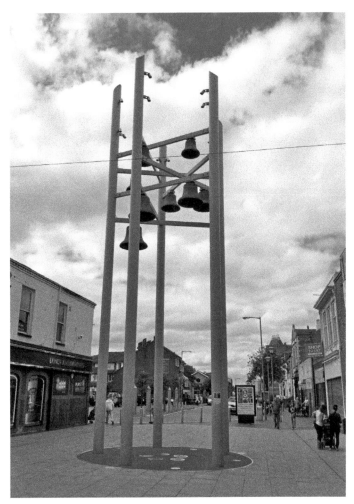

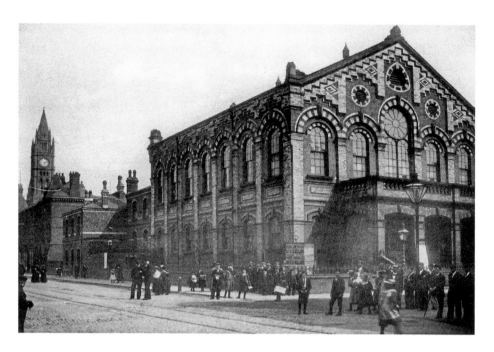

Wesley Central Mission aka 'Big Wesley'

Opened on Sunday 20 September 1863, the Western Central Mission stood on the corner of the junction of Linthorpe and Corporation Roads. The £900 organ installed in 1899 was said to have been one of the finest in Middlesbrough. Dating from around the turn of the century, the above photograph shows the town hall clock in the background. The last service was held in 1954, and British Home Stores now operates on the site as part of the Cleveland Centre.

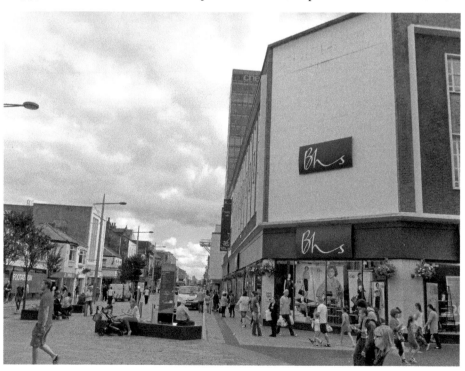

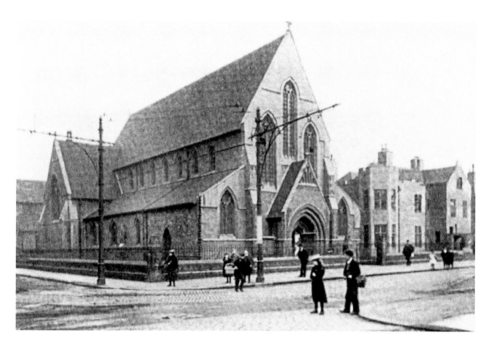

All Saints' Church

Known as the ironmasters' church given the significant financial contributions made by local Victorian industrialists, All Saints' was consecrated in 1878. The church's painted glass window was funded by the ironmaster John Gjers in 1890. On the corner of Grange Road and Linthorpe Road, All Saints' continues to serve worshippers in Middlesbrough today.

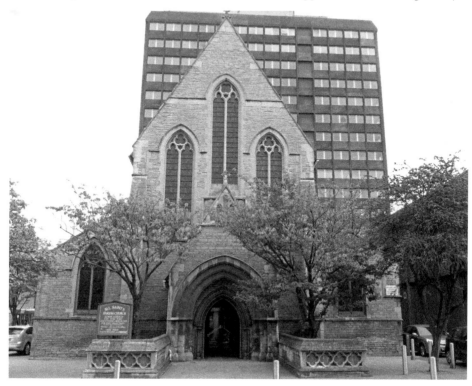

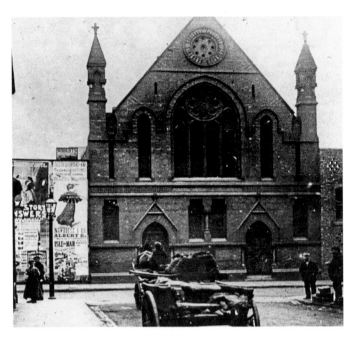

St Columba's Church

St Columba's church, designed in 1889 by Temple Moore, was built to serve the residents of the Cannon Street area of Middlesbrough. As well as fulfilling its religious function, the church played an important part in the community, regularly hosting bazaars to raise money for good causes in the area. While Cannon Street has gone, the church still stands over a century after opening and still operates today. The church now stands adjacent to a Sainsbury's supermarket and petrol station.

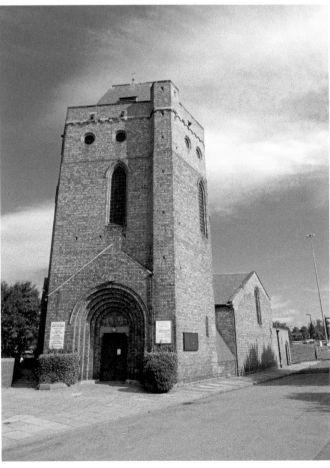

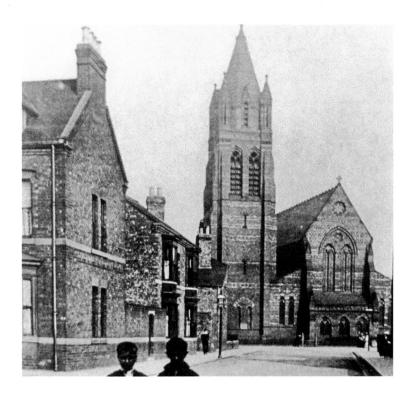

St John's Church

Dating from 1865, St John's church is one of two Anglican churches in the centre of Middlesbrough. The other is St Columba's church on the opposite side of the town centre. Situated on the corner of Marton Road and Ormesby Road, the church has undergone changes to its structure over the years with the gardened area and trees that were on the site prior to the First World War having disappeared. The building remains imposing and magnificent, and provides a close link to the past on the doorstep of the new St John's Gate area of the town with its fast-food outlets, restaurants, cinema and retailers.

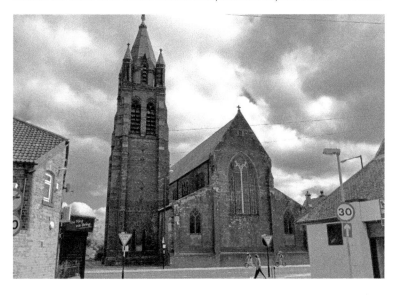

Acknowledgements

The development of this collection has been made possible by the advice, assistance and support of various individuals and organisations too numerous to list here. I am indebted to Jenny Parker of Middlesbrough Libraries for her support throughout the years in my research into the town's history. Without her expertise and guidance this book would not have been possible. Cori Dales, Ruth Hobbins, Helen Kendall, Michelle McCarthy, Stuart Pacitto and Kimberley Starkie of Teesside Archives have all provided assistance with archival material, while Middlesbrough Council's Safe & Active Travel and Transporter Bridge teams have been on hand with ongoing support. I am grateful to the University of Huddersfield's History Department for furthering my historical interest, with a special mention to Barry Doyle, Duncan Stone and Daniel Travers for their encouragement and advice throughout. The Arts and Humanities Research Council, Cleveland & Teesside Local History Society, Economic History Society, Teesside University and Urban History Group have also provided assistance in encouraging the development of this collection and exploration of Middlesbrough's heritage.

The encouragement of my family, including that of my late grandparents Mary and Paddy Boyle and late uncle Neil Harvey, all of whom passed away in recent years before this book went to print, has been invaluable. I would also like to thank my partner Ellen for her patience, encouragement and assistance both with photographs and in reading earlier drafts of this work. Special thanks also go to Dean Baker, Chris Brodrick, Joseph Brodrick, Steve Dauncey, Claire Dembry, Claire Enderby, Leon Green, Chris Harper, Louise Napier, Matthew Norton, David Parsons, Chris Stevenson, and Lucy Wood for their support over the decades.